DISCOVERING NATURAL PROCESSES

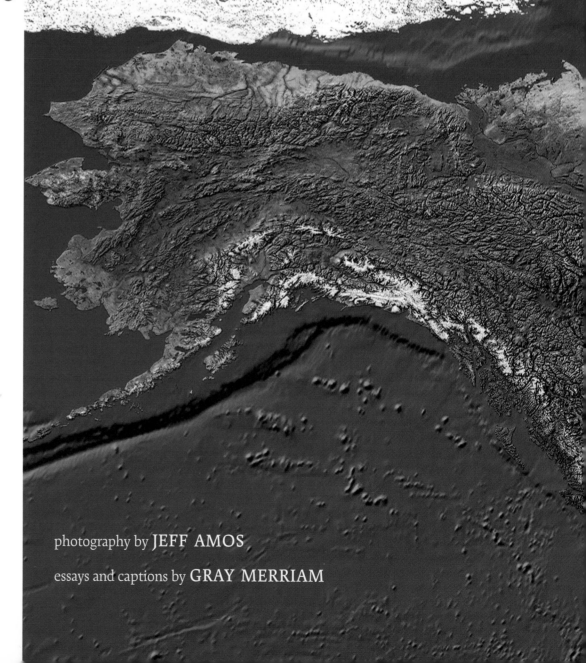

DISCOVERING NATURAL PROCESSES

beauty in nature's ways

PENUMBRA
PRESS

ARCHIVES
of
CANADIAN ARTS
CULTURE & HERITAGE
www.penumbrapress.com

photography by **JEFF AMOS**

essays and captions by **GRAY MERRIAM**

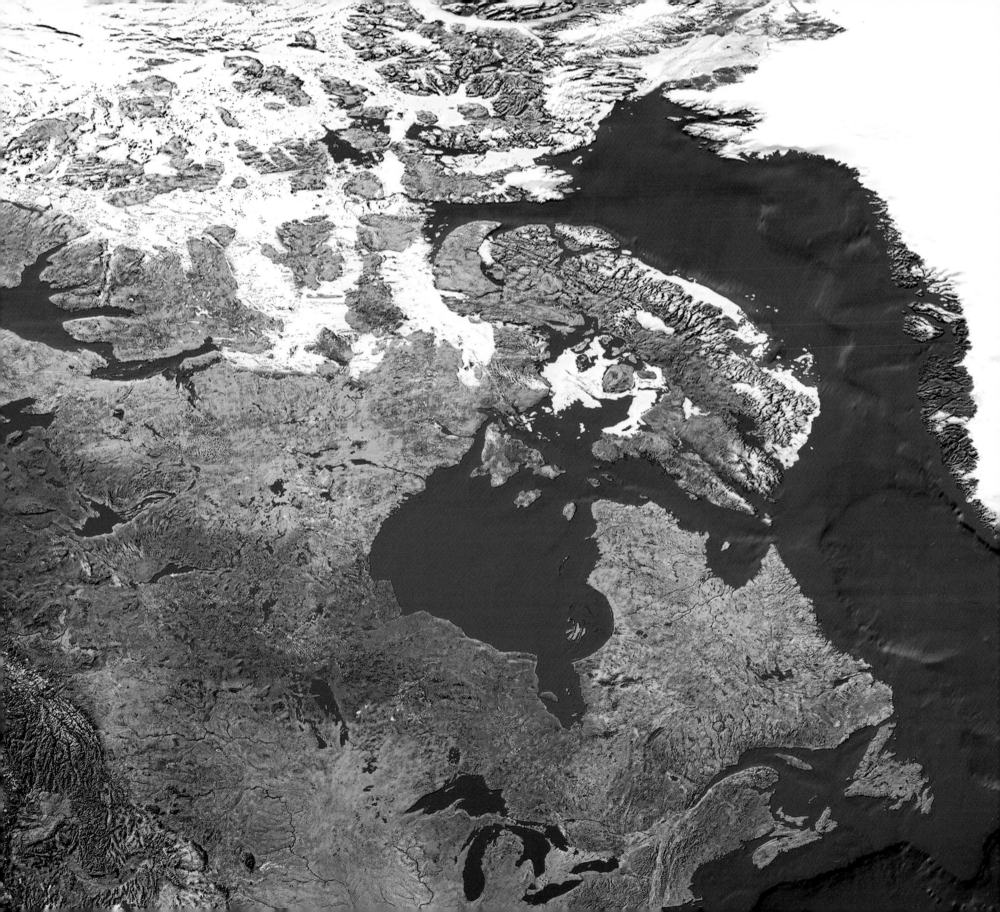

WE OFFER THE INFORMATION AND the images in this book to you whatever your range of experiences, your personal preferences, and your spiritual bent. Within those contexts, we trust that you will see the beauty of our membership in an interdependent community of living beings that together derive their existence from the sun. We also trust that your life view will be strengthened by the realization that we depend on self-maintaining systems of natural processes.

Our dependence on the sun relates ultimately to food energy but many interdependencies derive from that. Food is more than just energy. Nutrient composition of food also depends on that energy, and we depend on our nutrition. Science, reason, and technology can help us grasp the processes affecting those issues.

But the food producers also create sustenance for the spirit, in the form of aesthetic delights, magical happenings, and awesome spectacles. So we also need experience, intuition, and sensitivity in order to explore some of the natural processes that dictate the laws of the sun-based natural system that we share.

Such an approach is consistent with Asian philosophies and theologies, and is complementary to the Judeo-Christian tradition. The commandment in Genesis that gives man dominion over the environment has been re-interpreted in modern western cultures to refer to the currently popular idea of *stewardship* of the environment.

Our need to be sensitive to and to understand the basic elements of natural processes does not necessarily imply the existence of any moral law or spiritual meaning in those processes; they are not offered as a close link to any deity. Our need to pay attention to the system of natural processes arises from the assumption that natural systems are inscrutable, inhuman, and indifferent. This does not mean that we must fear or hate natural systems but only that we recognize they operate according to a set of laws that are insensitive to our codes of morality and our hopeful expectations. The sensation of a beautiful environment, if it is received without

consciousness of the laws and limitations of natural processes, is false, deceptive, and temporary. We need to pay attention, not just hope to gain pleasure.

A JOURNEY OF DISCOVERY

what are natural processes?

WE WANT TO GUIDE you on a journey of discovery. We want to help you to discover the beauty and the meaning of natural processes on your terms, no matter what your background.

What are natural processes? For most people the wealth of knowledge about ecology in scientific journals does not help to answer this question. There are many books about natural processes (and the unnatural processes affecting them), some recent such as Robert Bateman's *Thinking Like a Mountain*,[1] some everlasting such as Aldo Leopold's *A Sand County Almanac*[2] and some of spirit-stimulating images like Lanting, Rowell, and Doubilet's *The Living Planet*[3] photographed for the World Wildlife Fund. Still readers ask, 'What do you mean by natural processes?' Many have skipped over this question and focused, instead, on how we have affected natural structures and the processes that interconnect them.

This book attempts to ease the problem of understanding natural processes by showing photographs of their products, and enticing readers to understand the processes by interpreting images of their results. Readers should gain a comfortable grasp of natural processes from an interpretation based on their own personal knowledge and experiences. Spartan introductions to each topic are designed to guide the personal interpretations. Legends indicate the basic connections of images to natural processes without stifling either the aesthetic qualities of the image or the harmony of the reader's personal world view.

Jeff Amos has devoted his life to visual sensations, as a landscape photographer, and fine furniture designer and craftsman, but he has been trained in ecology and has strong roots to the land. Gray Merriam has focused on the science of ecology in a lifetime of research and teaching, and, in retirement, applies his knowledge of landscape ecology to stewardship of the land by the public. The challenge we set ourselves in this book was to come as close as possible to actually photographing natural processes, and where we fell short, to stimulate the viewer to interpret the image in order to view the process fully. It is difficult to capture crisp, aesthetic images of nutrient cycles, but we believe that many viewers and readers possess stored bits of information that will enable them to see those processes in our images. Where that fails, we intend that the images, apart from their instructional utility, will provide significant food for the human spirit.

We believe that the beauty, the texture, and the diversity of nature lead comfortably to curiosity about and personal interpretation of the natural processes that created and nurtured those aesthetic qualities. This book is intended to encourage that journey.

1 Robert Bateman. 2000. *Thinking Like a Mountain*. Viking.
2 Aldo Leopold. 1949. *A Sand County Almanac*. Oxford University Press.
3 Franz Lanting, Galen Rowell, and David Doubillet. 1999. *The Living Planet*. World Wildlife Fund and Crown Publishers.

THE START

our shared environment

WE SHARE OUR ENVIRONMENT with many other species. It has become clear that we are each ethically responsible for how we influence our environment and that we will pass on many changes to all the other species on the planet as well as to generations of our own species whom we can not consult. Our influences have effects from local to global and on time scales from next week to far into the future. Some of our influences may stay hidden in the ecosphere's memory to strike as chaos sometime in the future.[1]

It is tempting to simplify our obligation by focusing only at the level of the individual or the family or the backyard. The complexity is difficult at the community level, more so at the national level and seemingly unapproachable at the international, global level. System complexity is especially awesome when we realize that the ecosphere includes not just the lands but also the oceans and the atmosphere. It certainly is a challenge to 'fit us in' and do minimal harm to the ecosphere. But as ethical beings, we can not avoid the challenge. We simply cannot reach for the crutch of humanism and declare ourselves unaccountable to all the rest.

A comforting alternative to the insurmountable complexity is to find some basic principles that help us to understand how the system works. How do the wonderful structures of nature arise and how do they persist? If we can pull out the real elements of the system, we will be able to see past the wealth of variable detail that confounds a clear view. The basic elements will be valid at many levels from your backyard to the ecosphere and you, as reader and viewer, will be able to apply the degree of detail appropriate to your interpretation in the views that you choose.

Let us explore some fundamentals of an ecosystem. They will illustrate how a reasonably simple view will provide insights at many levels from the very local to the global and even to the whole ecosphere. Natural processes include those that are physico-chemical (or just plain physical, or abiotic) and biotic processes, those in which living things are prime forces. The functions of the system can be constrained, or limited, by physical limitations. For example, Canada has only a very limited area (less than 5 percent) in which food can be grown by agriculture. The constraints are caused by the type of rock, that limits the quality of soil which can develop from that rock, by climatic extremes, that limit both the soil development and growing seasons, and by mountain slopes that are too steep for agriculture. Consequently, calculations that divide the number of Canadians into the total area of the land are not useful for thinking about our national capability for providing the food that we need from Canadian agriculture. Physical processes can cause constraints and set limits that can not be overcome by technological 'fixes.'

However, organisms do not just accept the physical environment given to them. Organisms exert powerful biotic forces that modify the physico-chemical features and processes of their environment and make it more suitable to their survival. So, where they can, living things change their environment and live in it. But those very changes may also make it possible for some other types of organisms to move in, outcompete the pioneers and start their own modifications of the environment, only to be replaced in their turn. Living things will change physical and chemical features of

the environment where they can to improve their survival. They are a major force in forming the soil that can be produced from any particular bedrock. The radial growth of tree roots splits large rocks. Many plants make vast changes in the chemicals coming from rock particles and soils, both by their own actions and by harbouring special bacteria and fungi along their roots.

None of these strong living forces are possible without a power source for the living things in the system. That power comes from the energy of the sun. It can only be captured and fed into the living system by the magic of photosynthesis, a unique process made possible only by green plants — a wonder that we will explore in the section called 'Green Magic.' We call the process 'green magic' because it is the only process that can accumulate the tiny energy packets from the light particles called photons and make them powerful enough to form the high-energy chemical bonds of foodstuffs such as sugars. Truly magical — even with our advanced technology we cannot duplicate it! Plants store this energy from the sun in their tissues. From them the sun's energy flows throughout the ecosystem into herbivores and carnivores and decomposers. But all along these flows, often called food chains, a little of the energy is lost as heat every time the energy is used. Consequently, the eventual fate for all of this energy stored in living things is to become heat. You can't eat heat. You can only warm your hands on it. So, there is no such thing as energy cycling in ecological systems. Energy just dribbles away as heat as it passes through. Then, more has to be captured and fed into the system through the green plants. Plants truly do perform 'Green Magic.' Without it — no other living things.

In contrast to energy, matter in ecosystems does cycle. Plants, cows, lions, and all sorts of decomposers are able to store the energy from green magic by temporarily incorporating it in chemical bonds of the matter of which they are made. When that energy is removed from storage in the chemical bonds and used to do things, the matter is perfectly recyclable; it just has little energy

left in it. So decomposers can recycle matter back to the green plants who can recharge it with more energy from the sun. Matter can cycle, and does.

Cows and lions (herbivores and carnivores in ecolingo) lack an important ability. They can't trap sun energy. Consequently they have to get the power to do their work from green plants, either directly, by eating parts of the plants, or indirectly, by eating those who ate the plants. They are absolutely limited by their biology to a complete dependence on green magic.

Decomposers also are totally dependent on products of green plants, but they are easy to satisfy. They will eat whatever falls their way — dead leaves, cow things, parts from dead lions, each other — as long as it has energy stored in it. These primordial recyclers keep matter flowing back to the soil and into the green magic process. Without decomposers, the whole system would be limited by the rate at which nutrient matter is released by rock breakdown.

Decomposers are also responsible for directing a huge flow of the solar energy captured by producers into powering the processes of soil development and maintenance of nutrient regimes and flows. The decomposition process forms a loop for vital nutrients to follow from plants back to plants, without the long wait for new nutrients to be released from the rocks. Because decomposition is usually only partial, not complete like the burning of leaves, it also incorporates vital organic leftovers into the soil structure and its chemistry. Decomposers also add variety, from the leaf litter down through the soil horizons to the subsoil, and across the surface from moist hollows to steep little slopes to the tops of windswept and washed mounds of forest floor. The microtopography, the microclimates, and the tiny decomposers interact to add a measure of heterogeneity, which strongly influences the foundations of an ecosystem apparently dominated by big things like trees. We will explore 'decomposition' as a natural process because it is second in importance only to green magic

among the ecosystem processes that shape our 'home place.'[2] Besides, decomposition is fascinating and beautiful, both in its structures and its processes.

The magical ability of green plants to capture solar energy causes us to call green plants 'producers' (of high-energy matter). We call all the others who lack green magic — 'consumers.' When thinking of all the food chains in the food web and of the whole ecosystem, we may refer to the output of the green plants as 'primary production.' In recognition that all the others are actually doing important things, we can call their output 'secondary production.' The total of primary and secondary production is all the food available to everybody in the system. If all the organisms in the system eat more than the output of primary and secondary production, the ecosystem will collapse. This can happen easily in the whole system because the primary production from green magic attracts 'consumers' who have no other source of food. If too many consumers move in, they can, in total, eat more than the green plants can produce, and eat themselves out of house and home. If one type of consumer captures a larger proportion of the system's production, all other species will have less available to them, and their populations must be reduced. One species has been doing so disturbingly — us — and we will look at this later.

Changing the proportion of green photosynthetically active plant tissue also reproportions production and consumption and can create an even more subtle kind of imbalance. For example only a proportion of the tissue in trees has green magic. Wood has none (but has other qualities, as we shall see). So, as a forest ages, it has more and more woody tissue with no ability to produce food and proportionately less tissue able to make food. As this change progresses and more animal consumers accumulate in an aging forest, the total food used by all can easily exceed what can be produced by the magical green part of the whole system.

How then can so many animals, in number and in kind, live in a forest? The simplest solution is for many of them to go elsewhere for food and use the forest as cover for chewing their cud and hiding their young and sheltering from the storms. Where do they go to feed? To other habitats that have more primary production than the residents consume and so have some left over. Young forests, marshes, and farm fields are all good sources.

If a patch of marsh, with a surplus of production over its own needs, is next to a forest with no surplus of production, there will be a flow of food resources into the forest from the highly available food in the marsh. Animals, such as deer, will feed in the productive patch and carry that food into the less productive one. Such resource differences among habitat patches cause flows of resources across the mosaic of patches. Such fundamental linkages across mosaics of different habitat patches force us to think at the size scale of large landscapes when we consider what we mean by the 'ecological system.' These 'heterogeneous' landscape systems are the home turf of landscape ecology. It is a recent variant of ecology that deals in heterogeneous (or mosaic) ecological systems, which very often include the presence of humans and the results of our activities.

Of course, all of these natural processes, large and small, require water as part of the system. Water is a fundamental component of all living material because biochemical and biological processes only work in water. Beyond being a vital liquid, water is also the most important mode of transport and storage of heat in natural systems. When water is evaporated, it soaks up about 585 calories in each gram. Most of the heat that the earth must lose to prevent overheating makes its way to the atmosphere stored in vapourized water. The heat content of huge masses of water vapour gives water the power to exercise many regional, continental and global 'acts of nature,' such as hurricanes, climate zones and weather patterns. A most fundamental and vital phenomenon is the evaporation of water and its return to earth as precipitation. Without this, the oceans would be full, and the land barren for lack of water. Hence we will explore the 'water cycle.'

When starting this book, we assigned ourselves the task of illustrating the major natural processes with photographs to entice the viewers to discover the processes by interpreting the images in reference to each viewer's own experiential knowledge. The text has been constrained so that it will not interfere in that process. We do not aspire to make ecologists or photographers of you, but we desperately hope that you will enhance your personal set of values from the contents of this book. The planet, our continent, your landscape, and your backyard all need you to incorporate the major natural processes into your personal value systems.

1 See, for example, M. Scheffer, S. Carpenter, J.A. Foley, C. Folke, and B. Walker, 2001. *Catastrophic shifts in ecosystems.* Nature 413: 591-6.
2 Stan Rowe, 1990. *Home Place — Essays on Ecology.* Newest Publishers, Edmonton, Canada.

CANADA
the land

IT IS HUGE. From Pelee Island in Lake Erie (41 degrees 30 minutes N) to Ward Hunt Island on our north shore in the Arctic Ocean (83 degrees N) is about the same distance as from Pelee Island to Quito, Ecuador, on the equator. The great plains, in the middle of the land, are truly continental — about 3200 kilometres from either the Atlantic or the Pacific. Such a vast spread of land has an enviable array of environments and all that they can support, from polar bears and dwarf willows to the other extreme of Carolinian species such as magnolia trees and possums.

This land has a natural heritage of more ecological zones than any other nation state except Argentina. Canada's ecozones are arrayed across the latitudes. Environments range from Carolinian in the south, north past the southern farmland and the prairies, up past the boreal forest, the Hudson Bay lowlands to the mainland tundra, the arctic islands and the seasonal ice cap. The south-north banding of ecological zones bends around Hudson Bay and sweeps northwest along the arc of the Canadian Shield. The Rockies strike down from the Yukon and Northwest Territories with their altitudinal array of environments and cast their dry shadow out onto the prairies.

Canada covers almost 10 million square kilometres, but most Canadians live in less than a third of that in a 6000-kilometre strip only 300 to 600 kilometres wide, just north of our border with the United States. We have our reasons. One is food production. About one percent of the land is permanent ice caps — hard to farm. Another 4 percent is Canadian Shield — also not farmland. In fact less than 5 percent of our land is farmland. So when we calculate how much area we have per Canadian, from the food production viewpoint, we should consider that less than half a million square kilometres of the land is capable of economical agriculture. When Canada's population reaches 35 million people, we will have fewer than 4 people per square kilometre of Canada's total area. But we will have almost 80 people per square kilometre of agricultural land. Those different densities — a crude density of 4 per square kilometre versus a foodland density of 80 people per square kilo-metre — give significantly different views of our land.

Canada's agricultural land is not limited just by lack of development. There are real physical limits. A satellite looking down on the land east of Georgian Bay across to the east end of Lake Ontario shows a distinct boundary between two ecological zones — the Precambrian or Canadian Shield to the north and the arable zone to the south, where most Ontarians live (see p.14, 15).

The Canadian Shield sweeps across the land, northwest from Atlantic Canada, crossing just north of Parliament Hill, forming the northern boundary of the prairies and on northwest to the Northwest Territories, Nunavut and the Yukon — a truly Canadian landmark. Its characteristics and possibilities — and impossibilities — are to be celebrated, understood, and acknowledged.

On the Shield, granitic and metamorphic rocks combine with the short warm season to produce agriculturally unproductive soils such as podzols. Podzols are named, from the Russian, for an ashy-grey layer that is largely quartz sand with all its nutrient coatings removed by the acidic wash coming down through the soil from the boreal forest floor. Shallow, podzolic soils are largely

unfarmable. Less solar energy gives shorter growing seasons and lower temperatures. The climate, together with the poor soils, form an inescapable physical limitation on what is possible on the Canadian Shield.

The arable limestone-based zone to the south of the line in the satellite image received a lot of soil and rock fragments that were scraped and pushed and carried by the glaciers, about ten thousand years ago. Deeper, more fertile soils developed from this glacial 'till' and from the limestone bedrock. The higher input of solar energy made both soil formation and plant growth faster. Food production and other things, impossible on the Canadian Shield, are possible in this zone to the south. That line marking the south edge of the Shield is a hard and real limiting line that we must recognize.

But the Canadian Shield is productive in other ways. The heated, melted, and pressurized rock has yielded fortunes to mining. Forest resources harvested here have been a major contributor to the Canadian economy.

The Shield's overall ecological productivity is even greater than the yield from resource extraction. Much grows here and this non-agricultural area is a major contributor to ecological processes that are vital to the biosphere. Despite short growing seasons and growth rates limited by soils and solar input, the area of the Canadian Shield is so great that its total contribution to processes such as carbon storage is outstanding. As tropical forests are degraded, the value of the Shield to the planet increases. The huge area of the Canadian Shield and ecological zones north of it make one of the largest contributions to the total of all ecologically productive areas on earth. We will return to the topic of 'ecological footprinting' in later sections, where we will see the importance of ecologically productive areas in balancing the resource demands of Canadians and all humans on earth.

The Canadian Shield also is productive of food for the spirit. Human intercourse with the Shield began as survival, trapping and hunting and fishing for food. Our values are shifting toward recreational exploring by canoe, searching for solitude, research to produce new knowledge, and unguided celebration of the land. Many areas of the north are a glorious mosaic of forest fingers wrapped around lakes, bogs, marshes, and rivers. Canadians and visitors from many parts of the globe, especially from Europe and the United States, have flocked to our northern ecological zones, demonstrating the high value placed on these environments internationally. Few places on earth can give a comparable immersion in personal and philosophical recreation. Today's visitors to Canada's north have made terms like 'barrenlands' clearly archaic.

The rich aesthetic values of the northern landscapes have founded major artistic movements and sustain countless other artists with camera, brush, and poetic pen.

This 'unproductive' region north of the 'Shield line' is a magnificent and huge component of Canada's and the world's heritage.

We intuitively recognize rocks, soils, organisms, and activities that characteristically occur above and below the line of the Canadian Shield. The differences are real and the limitations lasting. We need to integrate them into our visions for Canada's futures and our planning for those futures. Clusters of silos will not appear on the Shield and vast forests with woodland caribou and the aesthetic values of old growth are not going to appear on the southern agricultural areas. As with any other rational enterprise, we must recognize real limits and alternative values and use them in our thinking.

What is reasonable on the land and what is not? We, as a technological, sociological, and economic community, are capable of putting strong marks on the land — whether good for the land or not and whether productive for our society or not. The satellite camera sees the border between Alberta and Montana as a sharp line. But the soils are the same on both sides of the border. So is the climate. The people look the same but their socio-economic

environment is different enough that their activities created this sharp line across the land. Just as we should acknowledge physical limits put on us by the land, we should also recognize our capacity to indelibly mark the land. We have developed a 'technosphere' that is capable of fundamentally changing the biosphere. And that thin shell of earth and air must continue to support us in the many situations and processes where we are not technically capable of complete, global self-support (see p.16).

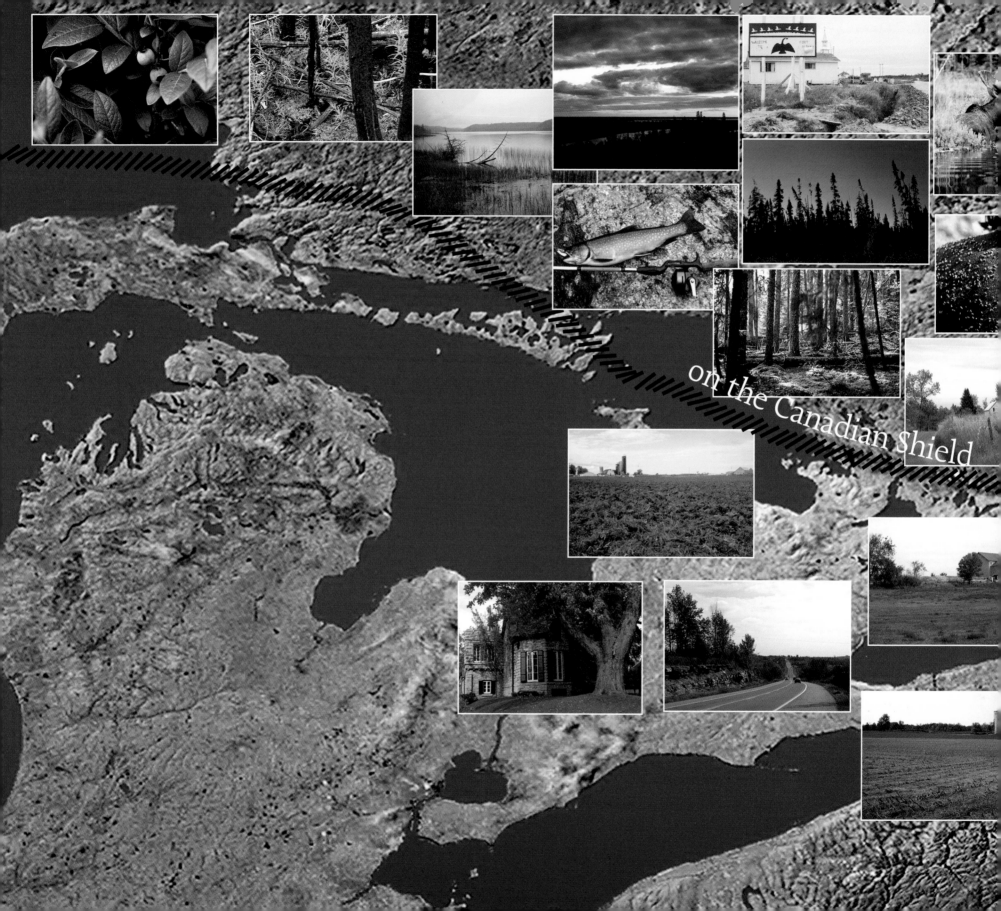

on the Canadian Shield

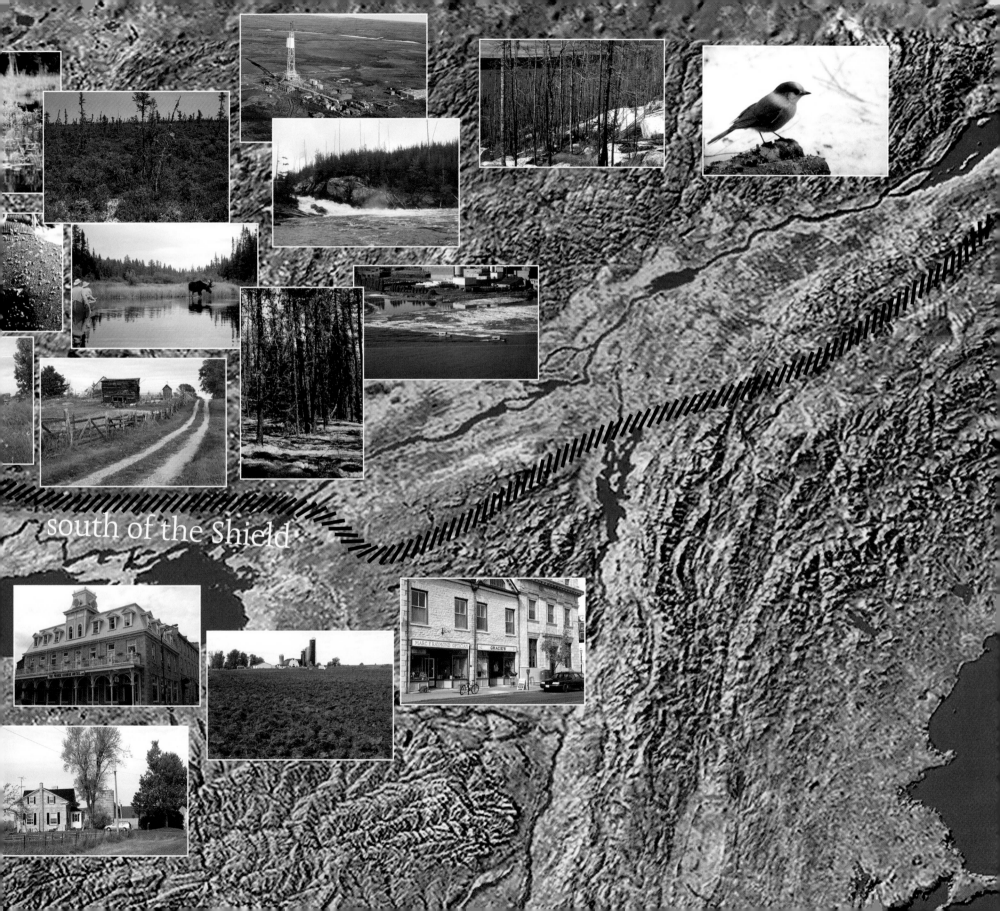

south of the Shield

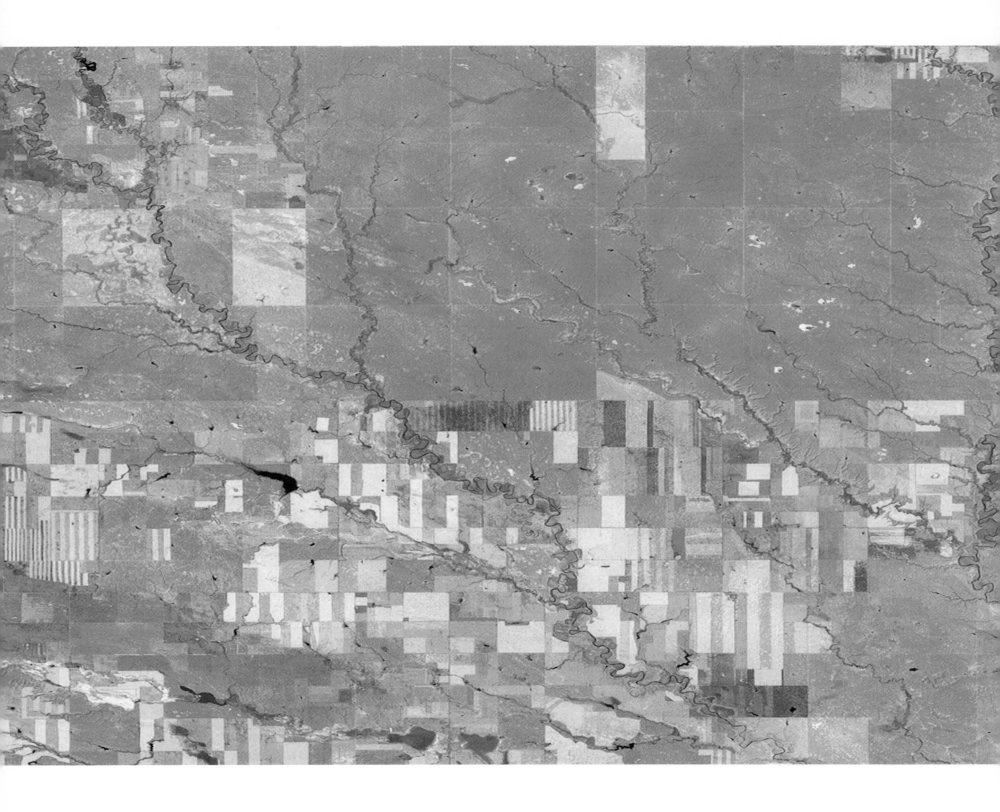

GREEN MAGIC

the power of plants

GREEN PLANTS ARE SPECIAL, not just as healthy, raw food for salads but because they are the source of all food for all living things. Green is important because it is the green pigment, chlorophyll, that is able to capture light energy from the sun and store it in foodstuffs such as sugars and starches. This process, called photosynthesis, (literally, building with light), builds solar energy into the chemical bonds of energy-poor carbon dioxide and water. These very common raw materials are turned into sugars to be stored in the plant, and oxygen to be released to the air. For practical folks, the magic in 'Green Magic' is that we have never been able to do it; only green plants can. For students of thermodynamics, it is magical because plants have the unique ability to capture the very small packets of light energy called photons and accumulate them into blocks of energy big enough to make the energy-rich chemical bonds in carbon compounds such as sugars. For all the other living beings, it is magical because it captures from the sun all the energy they need for life processes and sends it to them down all the food chains of the biosphere. Without energy captured by green plants, all living things would be without power. There would be no vital forces anywhere. Green magic indeed![1]

The energy stored in the products of photosynthesis is special because it is the only form of energy that serves as food. Photosynthesis is the only process that can make light energy into food energy; that is why we speak of green magic. Light energy cannot just sit around or it will turn to heat. For it to be kept as food energy, it must be stored in chemical bonds in molecules — the food. Only green plants can live by trapping sun energy; all other living things — plant eaters, animal eaters, and decomposers — depend on green plants to provide energy-rich food to them. This is why green plants often are called 'producers.' They do not produce energy, but they do produce foods like sugars, starches and proteins in which they have stored high amounts of energy — solar energy!

All other organisms, which lack green magic, are called consumers because they depend for their lives on consuming foods containing that solar energy originally trapped by the plants. Humans are among these consumers; all the energy that powers the life processes in our bodies was originally captured from the sun by green plants.

Only solar energy newly trapped by plants can flow along the food chains to power all the work that living things must do. Energy can not be recycled. Some of the high-grade food energy from photosynthesis is degraded to heat during every life process, every act of tissue-building, every act of self-maintenance, and every bit of work done along the food chain. Eventually it all becomes heat. Nothing can eat heat; it can only warm living things and reduce their need to generate their own heat. So, although green magic energy stored in chemical bonds in tissue can be moved along food chains and through the branches of food webs, the amount of food energy decreases at every link of the chain. Energy does not cycle in living things; it just dribbles away as heat, and so the plants must provide a constant flow from the sun into the food chain. Once it has turned to heat, energy cannot be recycled to power or to build living things.

Building living things is a spectacular result of the flows of food energy. Energy from the chemical bonds of food makes it possible for living things to build a new set of structures of their own kind, such as an embryo. The laws of physics require a lot of energy to organize matter into a structure as complex as a moose calf or a snapping turtle egg. Organizing such a structure opposes the otherwise universal dispersal of energy and the law of increasing entropy. Only with the energy from green magic is it possible to fight this powerful law even temporarily. Perhaps our reason for venerating vital forces is a recognition of the fundamental paradox that life is able to organize and build such wonderful structures in a world where the ultimate fate of all structures is disorganization.

Humans have built shelters and many other cultural amenities using the structural products of plant growth. We have used plant structures, alone and combined with inorganic materials such as stone and minerals, to form the infrastructure of our evolving cultures.[2] However, we sometimes forget that the plants themselves, without human aid, also have built structures of great and lasting value.

Success for plants comes from passing their genes along to their next generation, but in the process of doing that, green plants also produce our extraordinary natural heritage. The human spirit would get much less nourishment without the heritage of aesthetic splendors we receive from the plants. This heritage includes not only the beautiful structure of a trillium's blossom or a fox's bushy tail, but also the natural processes in a forest that support and maintain biodiversity; processes such as spring flow of sap, germination of seeds, and decomposition of fallen leaves. The dynamics of the structures that we admire are generated by these processes. The timing of the trilliums' appearance before the leaf canopy closes over them and blocks their sunlight, the grazing rabbit's ears twitching with plant power, and the chase that brought the fox's tail streaming past us — should remind us of the continually changing activities that support our natural heritage. These are the natural processes that are difficult to visualize, but we hope you will discover them in this book.

The natural heritage produced for us by the structures of green plants is overlaid on the inorganic landscape in patterns at many levels of viewing. Plants generate attractive patterns in a single germinating seed, in the blossom of a spring flower, in the contrasting hemlocks and oaks of north and south slopes of valleys, in the sequencing of vegetation types along the length of big river valleys, and in the distribution of ecotypes across our land from south to north and from west to east. Patterns produced by green magic form both the backdrop for our sense of place and an endless stimulus for our curiosity.

It is clear that we have both the technical power to obliterate major patterns from our natural heritage and the tendency to do so. Powerful disturbances such as large forest fires or the eruption of Mount St. Helens show us how sharply the destruction of these heritage patterns changes our environments. But these same disturbances also show us how powerful green plants can be in recapturing and reshaping their environment and that of all their co-inhabitants, including us. However, we ought to pay attention to the waiting period that follows in the wake of removal of the heritage left by green plants. There can be a long period of stark and unstable environment following severe disturbances. The big disturbances, such as large clearcuts, are noticed now, but have we learned to sense our disturbances of the underlying natural processes when the major structural features are not immediately affected?

We can change sets of natural processes and some function will persist. But how much change will our familiar environments tolerate? Move the question to the level of the planet and ask it again. How much are we changing the global production of food by green plants, and is that process, which supports all living things, continuing to function normally? All species depend

on energy flow from green magic. That energy flow ultimately is limited by the fact that the amount of solar energy that falls on each square metre of the earth's surface is fixed and beyond our control. The proportion of that limited energy income that is captured by green plants ultimately limits the energy available for all species. Energy capture by green magic depends on the extent and the type of green plants—something that we humans can and do influence.

The energy made available by green plants to all the species in one habitat patch, or a whole landscape, or a whole ecosystem also depends on how much the green plants need for their own purposes. The fundamental force driving green plants to carry on their magic is survival of their own species. Work, such as moving sap up a tree, renewing leaves, and building flowers must be done if a plant's genes are to be passed to future generations. Only the plant's net production—the surplus remaining after its own needs have been met—will be available to species that are non-green consumers.

Parts of a plant that can't do photosynthesis, like consumers, also depend on surplus production. Roots and wood must get their food supply from the green parts of the plant. Young saplings have a much greater proportion of green tissue than old trees with all their woody tissue. A patch of reedy swamp is mainly photosynthetically active tissue. A patch of sprouting poplar suckers has a lot of green leaf material and stores energy from the sun at a very high rate. But an old oak forest uses a lot of wood to support only a small proportion of leaf tissue, and has a much lower net amount of food left after feeding itself. In addition, as such a forest ages, additional animals that have no green magic move in to feed from the plants. The combination of non-green plant tissue and non-green animal tissue can result in no net production. Sometimes there may be a deficit. The amount of net production by the plants is a major force shaping the biodiversity and the landscape ecology of an area. We shall return to these topics later.

But we humans need to think deeply about the net production that we leave in an ecosystem for use by all the other members of that ecological system; we often take more for our use than we are willing to leave for all the other species. In fact, we often label any production left on the land as 'waste' — a homocentric view that lacks ecological understanding.

Sprouting poplar suckers and even older stands of polewood poplar are nutrient-trapping mechanisms in the landscape. Their rapid growth and tissue production soaks up nutrients such as nitrogen even more effectively than corn does. Shrubs and herbs also can trap nutrients. Only plants are able to take nutrients from the soil and the air and put those nutrients into the food chain for all the other species.

Nutrient trapping prevents nutrients from moving down through the soil into the ground water, and keeps them from washing off the surface of a site. In effect, this process reduces the leakiness of the system. Accumulating nutrients on a site and keeping them there over time is a fundamental process in ecological self-maintenance. Maintaining nutrient stocks by natural processes does not work in most types of farming, because so much nutrient is removed in what is harvested and carried away from the field. Harvest of timber or maple syrup also carries away nutrients that must be replaced to maintain production. For self-maintenance of nutrient supply, no more nutrient can be removed from a site than is resupplied by new nutrients. Decomposition can recycle only the nutrients left on the site. If tops and limbs or straw are removed, less can be recycled. Plant material left on a site to decompose — including bark and wood — is not wasted. Everyone recognizes this principle of resupply in restocking their kitchen cupboards by shopping. Green plants can't go to the mall; new nutrients come from rock breakdown, from air and from material carried on to the site from elsewhere. The only major nutrient that is freely delivered to a site is carbon dioxide. Plants build much of the bulk of their products from

carbon dioxide taken from the air. We humans have become entwined in this process.

Oxygen is released when green magic makes carbon dioxide and water into carbohydrates, such as starch or sugar. Although many have expressed concern about reduction in this oxygen production, there is good evidence that we will never deplete our huge atmospheric supply of oxygen. There is just too much. In the past, huge amounts of plant matter were produced and a correspondingly large amount of oxygen was put into the air. Much of that plant material was buried deep in the earth in high-carbon shales before it could decompose. That plant material did not use up oxygen by decomposing, so the oxygen produced in building it is still in the air. We can't reach the carbon shales to exploit them, and so we will have oxygen to last, even if we do all the wrong things.

No, the concern is not too little oxygen,[3] it is too much carbon dioxide. Carbon dioxide is released by our exhumation of the dead plant matter that we can mine profitably and are exploiting as coal and petroleum. But that is only part of the imbalance we have caused. Besides burning coal and oil and gas, we also have cut down and burned a lot of wood, and we have plowed up a lot of soil organic matter and allowed nature to 'burn' it by oxidizing it in the air, turning it into carbon dioxide. Beyond that we also have decreased the amount of wood that is allowed to grow on earth by replacing a lot of forest with agricultural crops and subdivisions and other tree-unfriendly structures and developments. But, you say, crops also soak up carbon dioxide. True, but they do not keep it for long. In a year or two the carbon stored in farm crops is turned loose into the atmosphere again after a brief detour through a liquid manure tank, or a feedlot, or us. This 'carbon cycle' is another natural process closely associated with green magic and we humans are deeply involved.

How we change the cycling of carbon could have important impacts on the environment of our children. The tropical forests have been major storage depots for carbon, keeping it out of the atmosphere for hundreds of years. Now, so much of the tropical forest has been cut, and so much of it burned, that another forest looks like the most important future storage depot for carbon. That other forest is the boreal forest or northern spruce-fir forest familiar to many Canadians, Scandinavians, and Russians. Green magic has a short season in the boreal forest, because of the climate. And the structure of the forest does not allow large amounts of carbon to be stored in wood. Instead, partly because of the limitations of the climate, much carbon, trapped by green magic, stays in the litter and the organic layers in the soil, and decomposes only slowly. This store of carbon is huge because it occurs over a very large area of the northern continents. Consequently, as the tropical forests are removed, the boreal forest is becoming the earth's largest carbon storehouse. Which will be more valuable — paper pulp or tonnes of carbon kept out of our atmosphere? Can we have both? Do we need to?

The boreal forest wraps the northern hemisphere like a green cloak spanning some 12,000 kilometres and covering close to 11 percent of the planet's surface. Forest ecologists estimate that globally, the boreal forest litter and soil, including peatlands, may contain almost four times as much stored carbon as do the trees and their roots. Canada's boreal forest contains more wetlands, lakes and rivers than any other ecozone on earth. The Canadian Boreal Initiative intends to increase the public understanding of these and other values of the boreal — one of the world's greatest intact forest ecosystems.

Humans compete with all other species for the energy-rich food and other by-products of green magic. Almost all the former habitat of prairie species, such as bison and prairie dogs, has been plowed and turned into wheat and corn farmland. Competition for

resources vital to all living beings is one of the most fundamental moral issues for us. It is estimated that we humans — just one of all the species — take for our singular use about 45 percent of all the production from the green magic of the plants. The estimate is the same for land and for oceanic production. That is a remarkable share for just one species. The question of how that share will increase as our human population increases, both in numbers and in consumption, sharpens the issue. Because green magic is possible only on those portions of the earth's surface where plants are allowed to grow, part of the question is: how much area do we allow to remain productive? That is, how much productive area will we protect from our human-centred activities?

'Ecological footprinting' tries to make an account of such human dependencies. Currently each human on earth uses all the productive capacity of about 2.8 hectares even though there are only 2.2 hectares per person of biologically productive space on the planet. The conundrum gets personal when we look, not at the average human, but at each Canadian. Each one of us uses resources that require 7.7 hectares of green magic space. And each person in the USA uses resources from 12.3 hectares of ecologically productive space. Yet we all still have only 2.2 hectares available for each person on earth. So when we take account of the total resource demands by humans, it is over 100 percent of the space available to produce those resource flows. About 85 percent of global resources are used by the rich northern and western cultures leaving only 15 percent for the highly populated poorer cultures. Many starve.

Human appropriation of 45 percent of the total production of all green plants — both human food and other plants — is at the root of this overwhelming demand but it is only part of it. Some of the other parts are those activities that eliminate green magic from areas where it was once possible. Suburbs, oil fields and roads are easy examples. So how does this environmental deficit spending work? Just like the deficit spending that results in business failure. We overuse our own productive areas, then we send afar for goods from the productive areas of others, and in all cases we eat right into the infrastructure that is needed to let the green magic happen — the natural capital of the system. Just like a factory selling its production machines to pay its debt. A certain path to bankruptcy.

The differences among nations in how much area they supply for green magic is striking. Canada provides more area for green magic than is required by our resource demands. The USA and Denmark demand twice what can be produced by the support area they supply, Switzerland almost 3 times[4] and Singapore draws from 12 times the area that they supply. Vancouver and some other cities draw from over 20 times their own area. If developing nations move into similar patterns of consumption, our global capability for green magic will not sustain human consumption of resources.

But this argument is totally self-centred; it completely avoids the moral issue of destruction of the other species and the natural capital that supports them. It really is not enough simply to assume a humanistic attitude and continue to dominate without facing this issue. Green magic is the only source of food energy for all species, and if we continue to overuse the natural capital that supports that magical source, we should recognize the unavoidable result and our role in it.

1 True, there are minor exceptions. Some organisms get their energy from chemical compounds that never have been touched by a plant. But these chemically 'reduced' compounds are available only from cracks in the earth deep in the oceans and feed very few species.
There also are a few organisms other than green plants, such as purple sulfur bacteria, that have forms of photosynthesis, but they contribute little to global production.

2 During our evolution we humans have learned to store and use energy for purposes other than food. We tried, with partial success and some failure, to change from storing and burning coal and oil and storing and releasing water to doing work by releasing nuclear energy. None of our intellectual effort that made us one of the most powerful of species gave any relief from our dependence on green magic. In fact, some of those efforts to develop a new and unique energy niche may have negatively impacted the environmental support systems for green magic.

3 Demonstrated long ago but often mistakenly overlooked. See: W.S. Broecker, 1970. *"Man's Oxygen Reserves."* Science 168:1537-8.

4 As a sample, the areas used per person to supply current resource consumption compared to the area still available for photosynthetic production in the nation are: for Canada 7.7 used but 11.2 available, for USA 12.3 used but only 5.6 available. See, also, for example:
W.E. Rees, 2000. *"Patch Disturbance, EcoFootprints and Biological Integrity : Revisiting the Limits to Growth."* Chapter 8 in L. Westra, D. Pimentel, and R. Noss, (eds), *Ecological Integrity: Integrating Environment, Conservation and Health*. Island Press.
M. Wackernagel, L. Onisto, P. Bello, A.C. Linares, I.S.L. Falfan, J.M. Garcia, A.I.S. Guerrero, and M.G.S. Guerrero. 1999. *"National Natural Capital Accounting with the Ecological Footprint Concept."* Ecological Economics 29:375-90.

Maple leaves are truly special. Not only are they Canada's symbol. They also contain the world's only technology for transforming sunlight into food. After a full season of green production they create a spirit-raising climax as their green gives way and releases a tapestry of autumn colours.

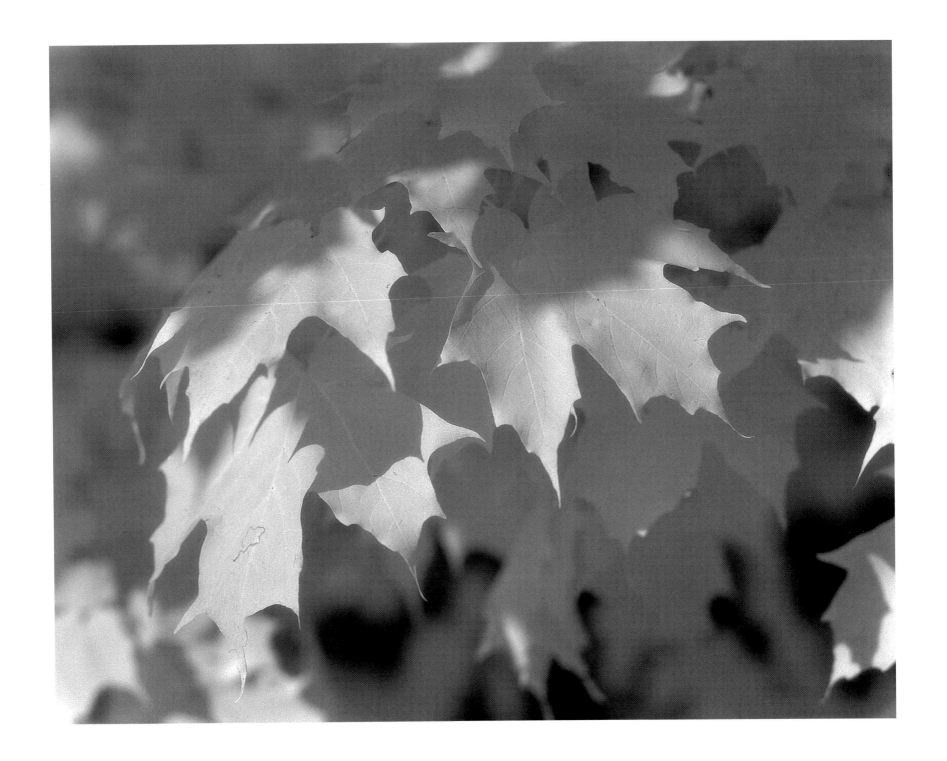

The sunlight seen falling on the forest is beautiful — but the beauty inherent in the green magic happening here is beyond words. All the energy to build these magnificent trees was captured by them from the sun. Only the sun is a great enough source of energy to support ecosystems and only green plants have the natural process called photosynthesis. This most fundamental of the natural processes captures and stores the sun's energy in chemical bonds that living things can unzip to release the energy for their own needs and the needs of all life forms along the chain. No life forms can survive and the work of life cannot be done without this special energy — from green magic.

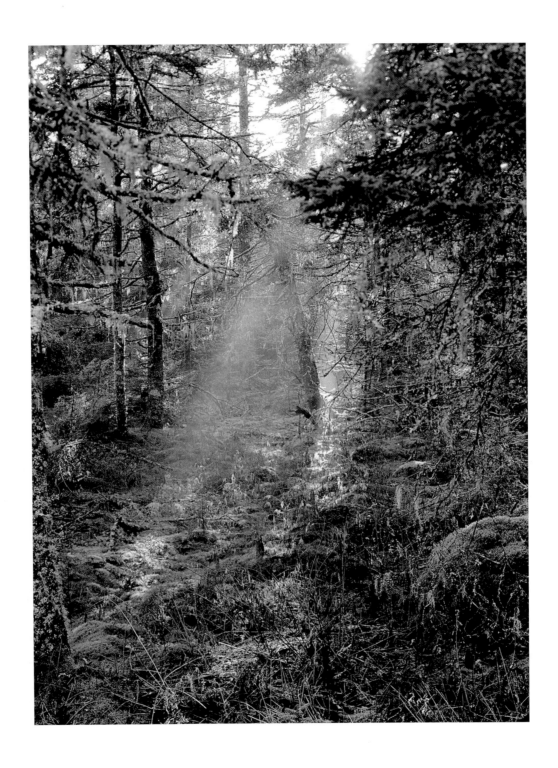

A complete forest is too complex in all its parts and processes for us to see easily. In our attempts to interpret images of a forest, or any ecological system, the process of production of biological mass by green magic is more fundamental than all the variety of forms. Without the green magic — no forms. But, as always, without the forms — no green magic.

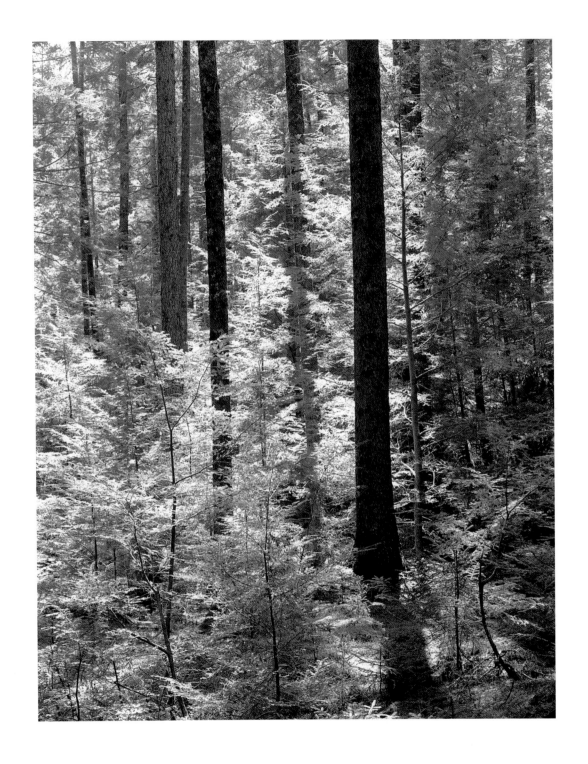

Green plants are called 'producers' because they produce energy-rich food for all other kinds of organisms. All the others are called 'consumers' because they lack the ability to make their own food. Green plant 'producers' do make the food primarily for their own needs. They need food-energy for themselves to do work that plants must do such as building their own structure and, most importantly, reproducing their own kind and passing on their genes. Production beyond the absolute needs of the producers can be taken by the consumers. These are the most basic processes of an ecosystem.

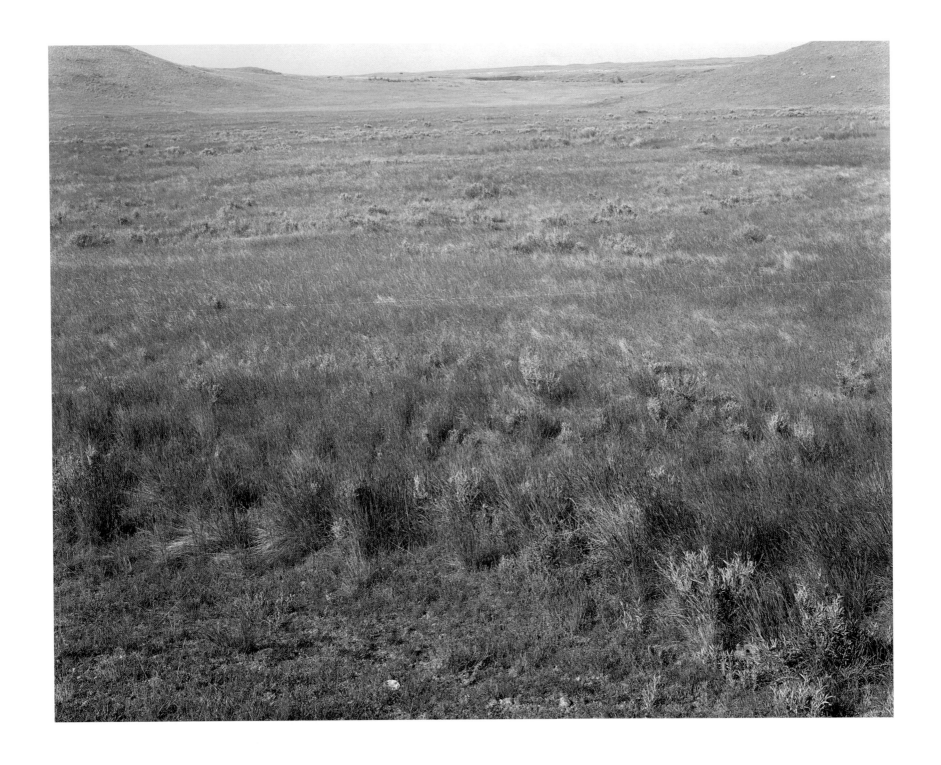

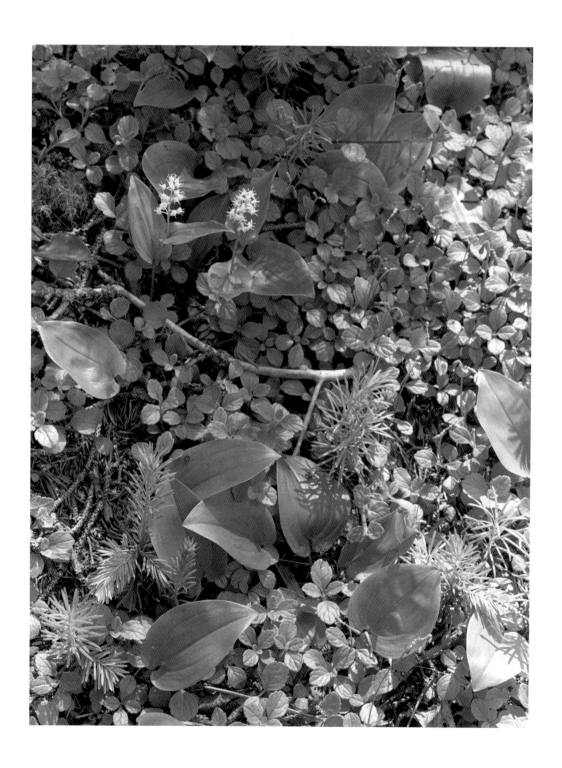

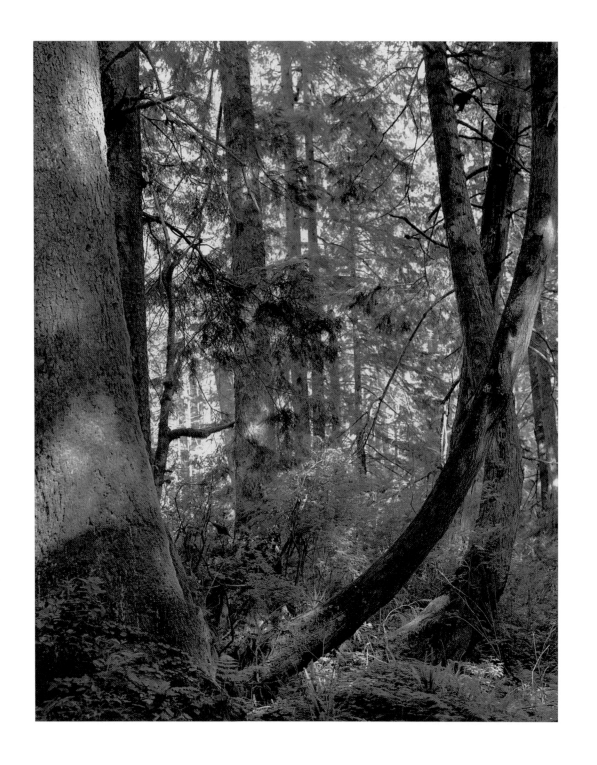

All structures built by plants are highly organized. Some more than others. Organizing a structure requires considerable energy because the tendency in all systems of matter and energy is for chaotic or random dispersal of energy — an increase in entropy. Living organisms oppose this tendency by organizing very complex structures and concentrating energy.

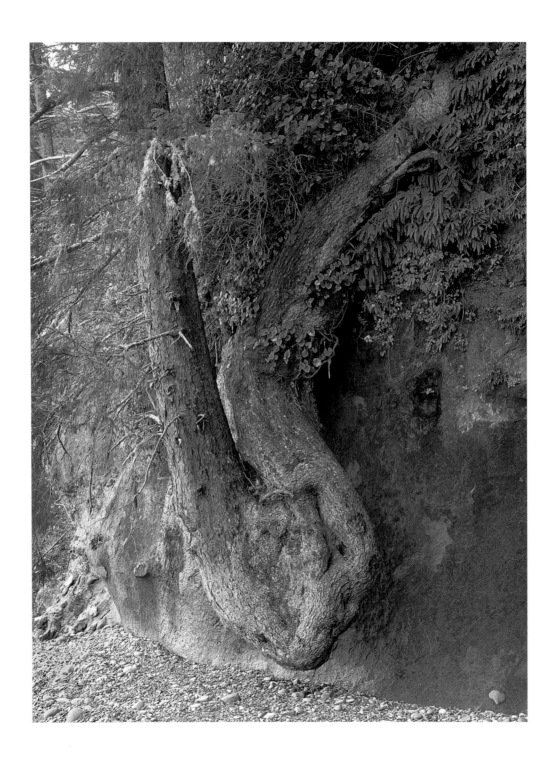

The history of mankind would be remarkably different without the artefacts that have been created from plant parts and products. It is impossible to imagine humans as hunter-gatherers without plant materials as their tools. Although we have substituted many synthetic materials into previous roles of plant products, they cannot yet be replaced in several critical roles — particularly roles related to aural and visual aesthetics. Is it even possible to assess how much of our intellectual base of designs and aesthetic values arose and persists in response to the structures formed by plants?

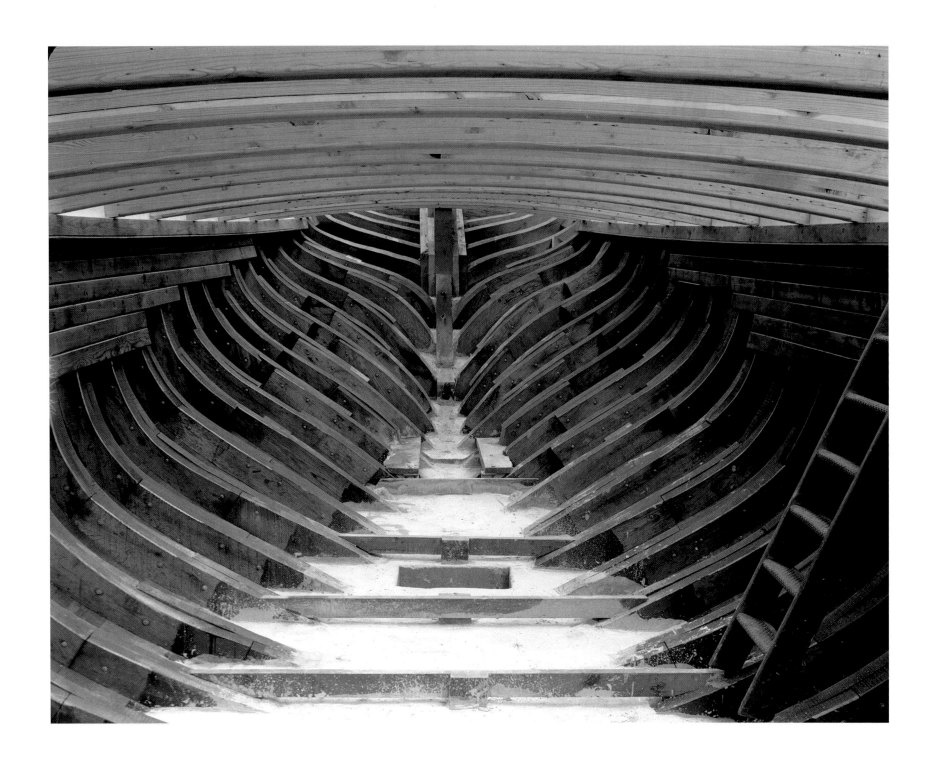

Appreciation of the natural forms of trees can be incorporated into practical furniture by creative designers and craftspeople. Natural forms of whole plants and their tissue patterns combine with geological and mineral patterns to take the human creative spirit to high aesthetic values.

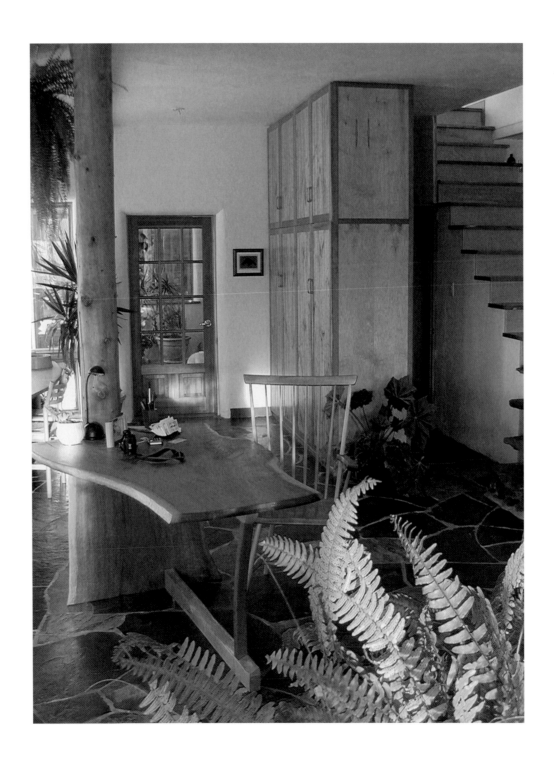

Beautiful forms and patterns produced by plants in nature shape our environment, raise our spirits and improve the human condition.

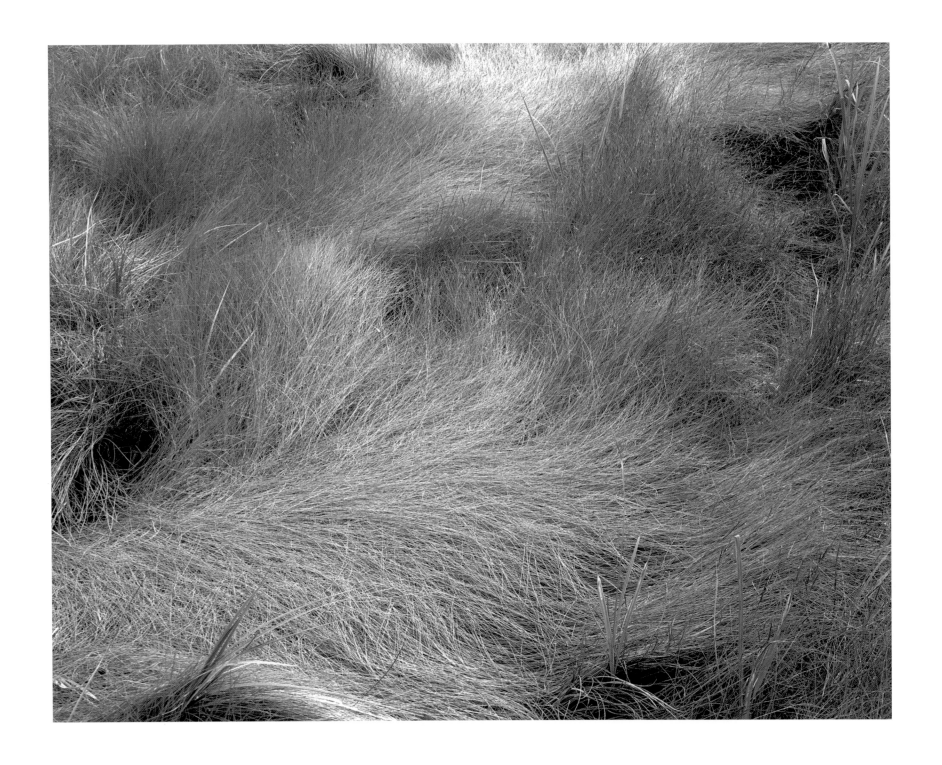

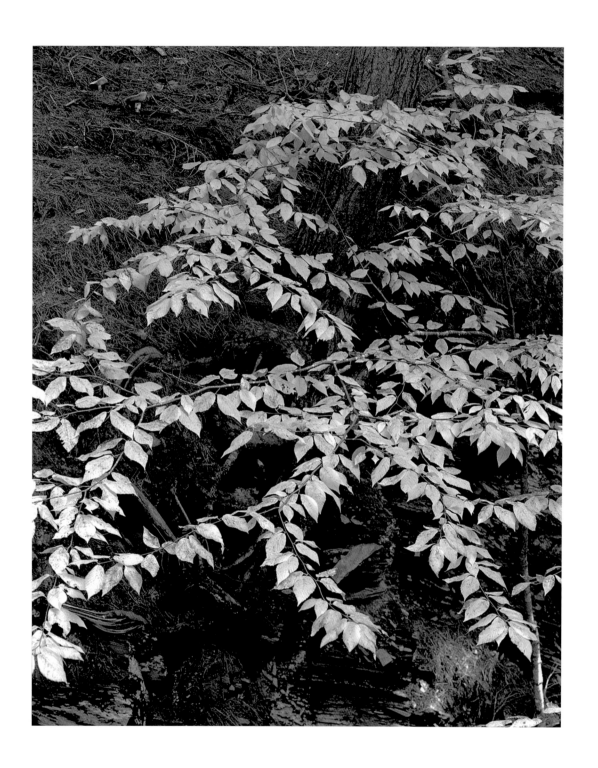

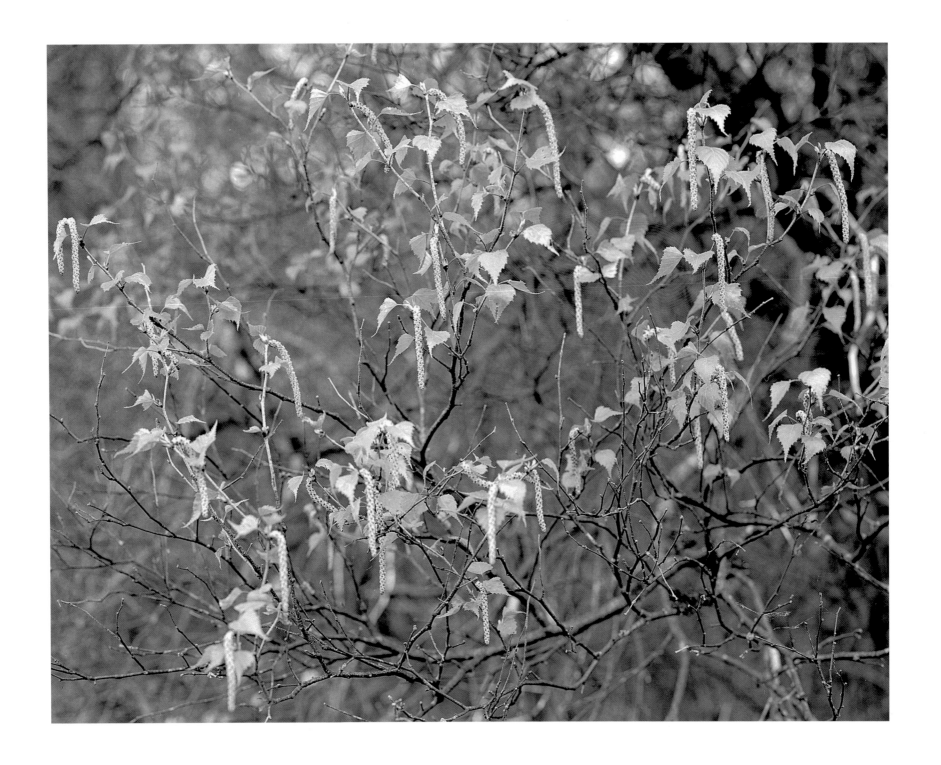

Patterns produced by green magic are among the best indicators of environmental differences. Interpreting those patterns at any level from the aesthetic to the analytical gives the foundation for our sense of place. Our curiosity about those patterns, their components and their geography add direction and enrichment to life's wanderings.

Bunchberry, mosses, lichens, and trees — all have the magical power to build themselves using energy from the sun.

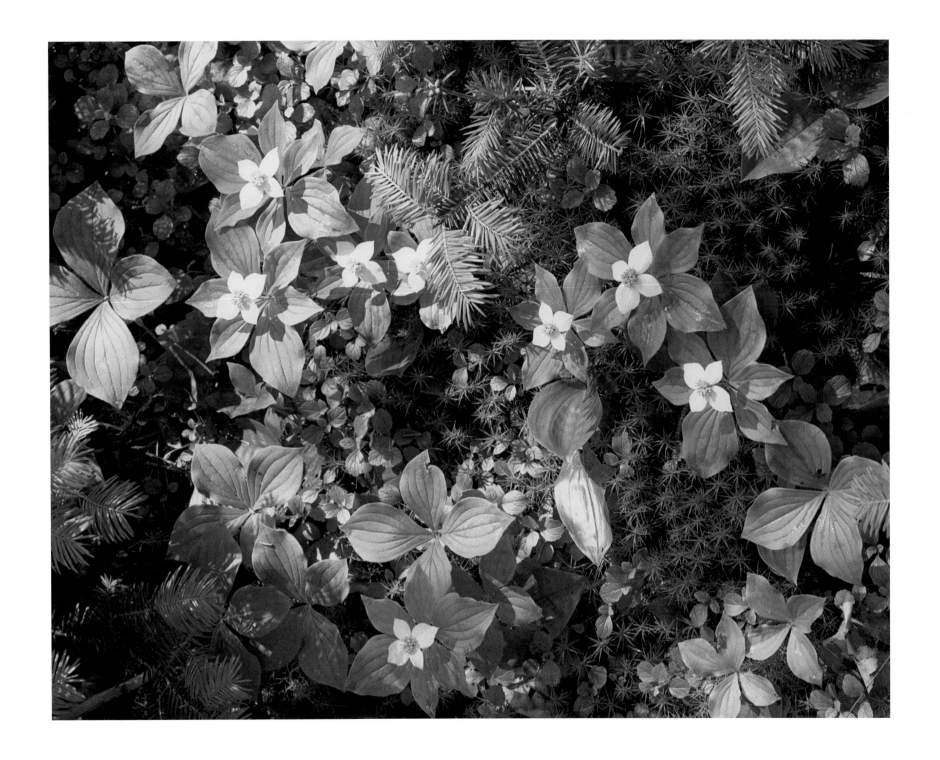

Big clearcuts or extinction of a species register with us as disturbances with impacts on ecological systems. How about a shift in proportion of native to invading species? How about a small, significant decrease in the average lifespan of female snapping turtles or loons? Are we sensitive enough to subtle changes in natural processes or are we sensitive mainly to big changes in natural structures?

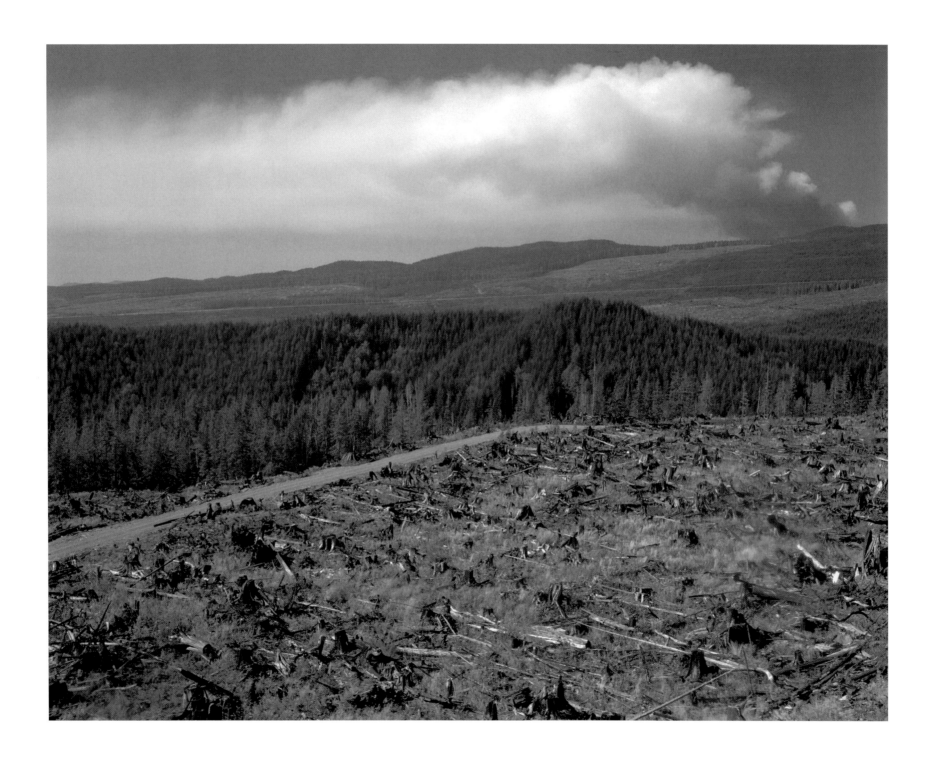

Yearly production of living matter by plants far exceeds total annual industrial production of goods by humans. Highest production is in young poplar saplings and in marshes called reed swamps. Both store more energy than they can use, and so they become food sources for other parts of the land. Some plant growth not used immediately is stored as roots, bulbs, seeds, tree trunks, and eventually, soil organic matter. Harvesting is instant removal of large amounts of plant growth from the slow natural processes of growth, consumption, storage, death, and decomposition. Harvesting removes energy, plant nutrients, and organic matter. If we want natural processes to continue, enough must be left for them, too.

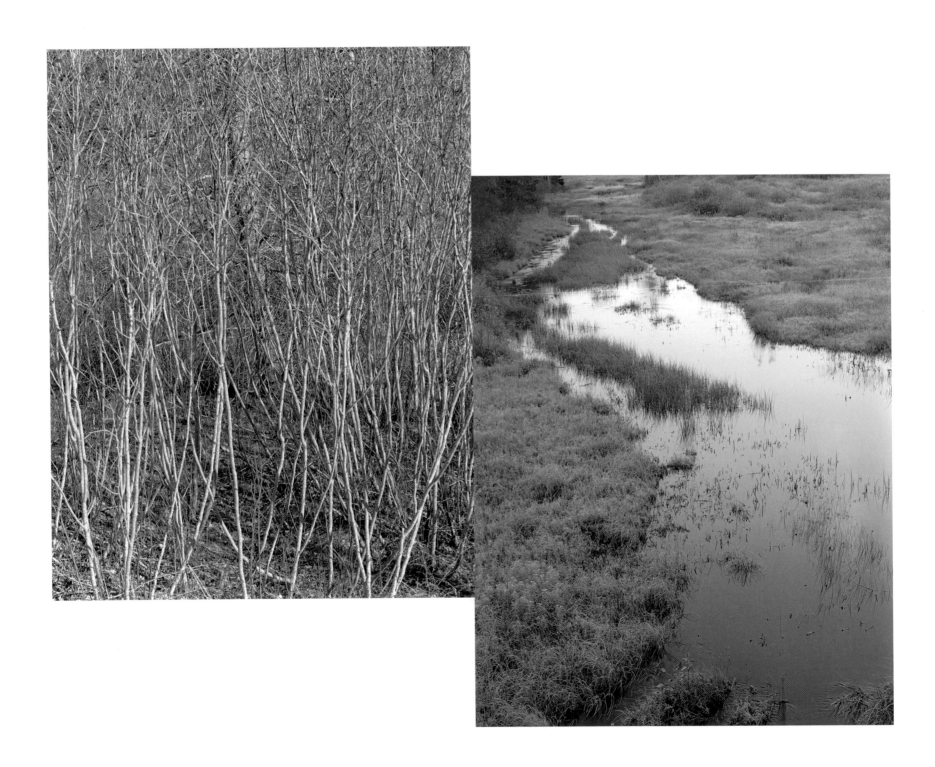

Plants have many parts that lack green magic. Tree trunks contain important plumbing and carry out vital processes, but, lacking green magic, they have to get all their food from the green magic in the leaves. As trees grow older, the proportion of their tissue that 'freeloads' increases. Add to this a growing horde of 'freeloading' herbivores, and the green magic of a forest can become unable to support it all. Natural bankruptcy. Pink slips!

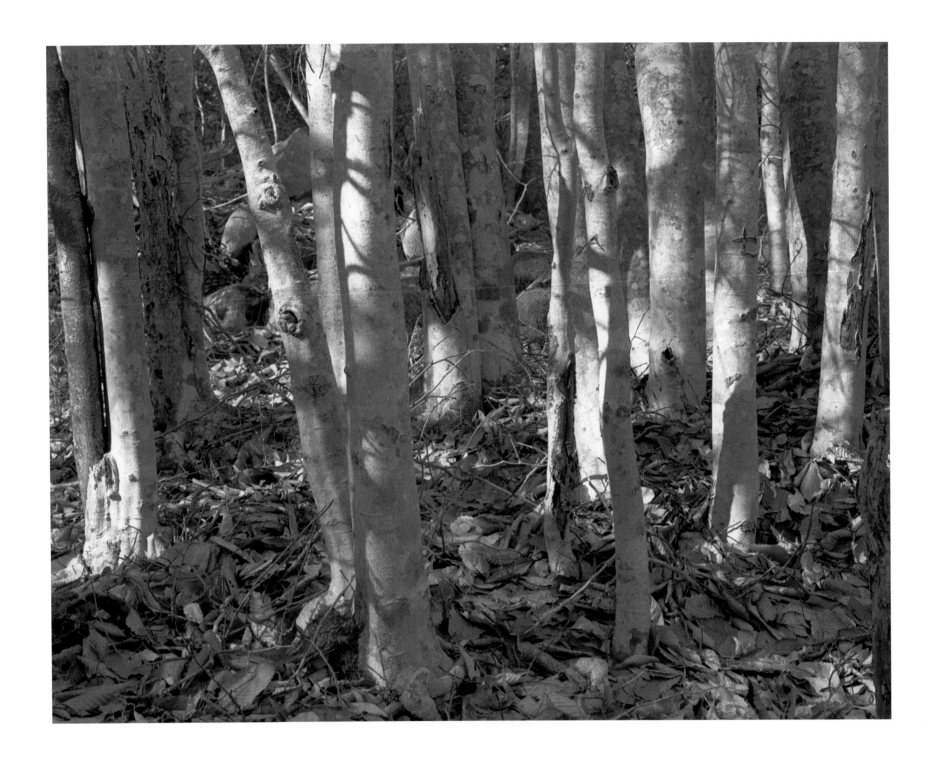

What produces the most plant matter on earth each year — farm crops, trees, or all the other green plants? Which plants have the greatest effect on us — on our sense of beauty, our hunger, our material wealth? Should we stress a few or value all the products and effects of plant production?

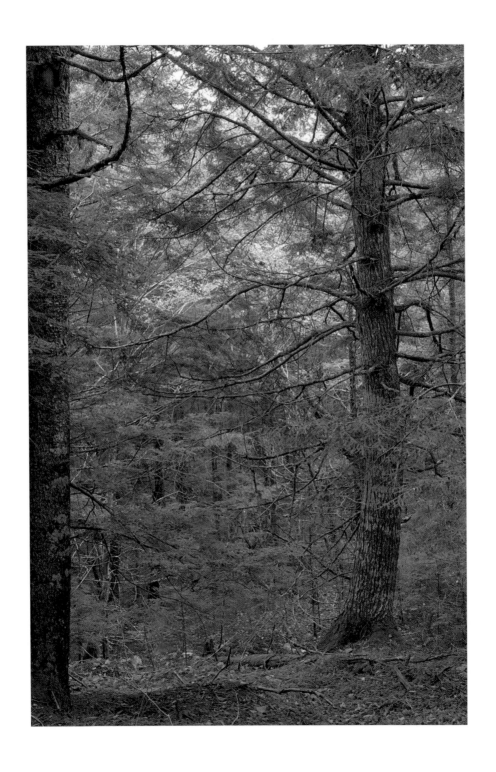

Green magic sculpts many forms. Canada bunchberry, fern fronds, filigreed pine needles. Throughout the diverse plant communities, soft, temporary structures are integrated with solid, lasting forms into working wholes. All are food for plant-eaters, but the beauty of plant forms and the intricacies of their relationships make them much more.

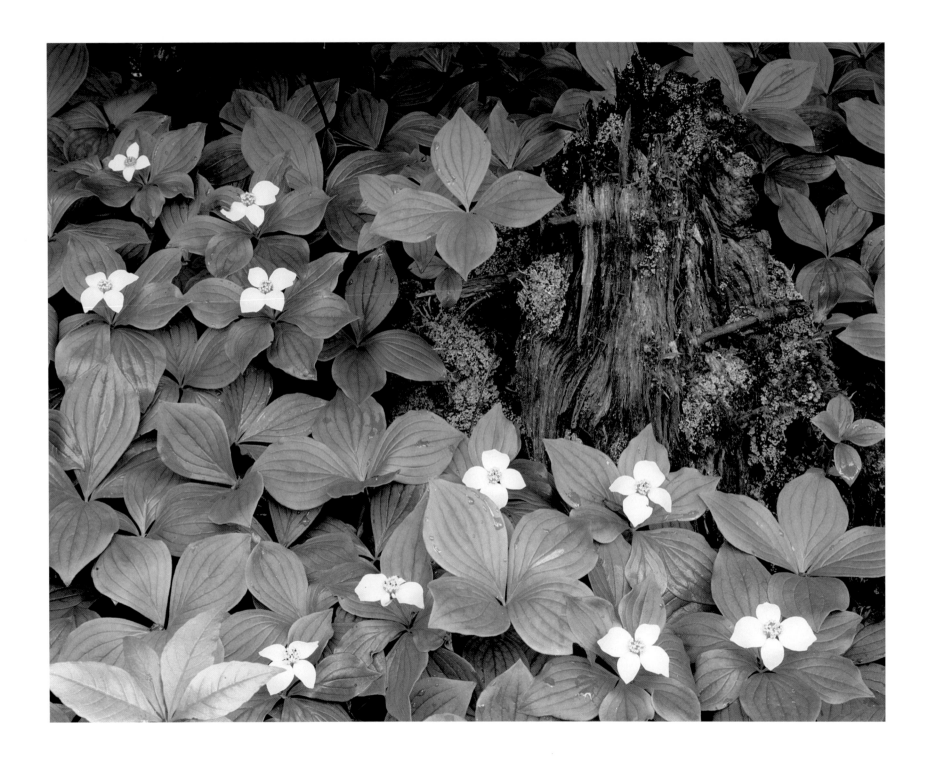

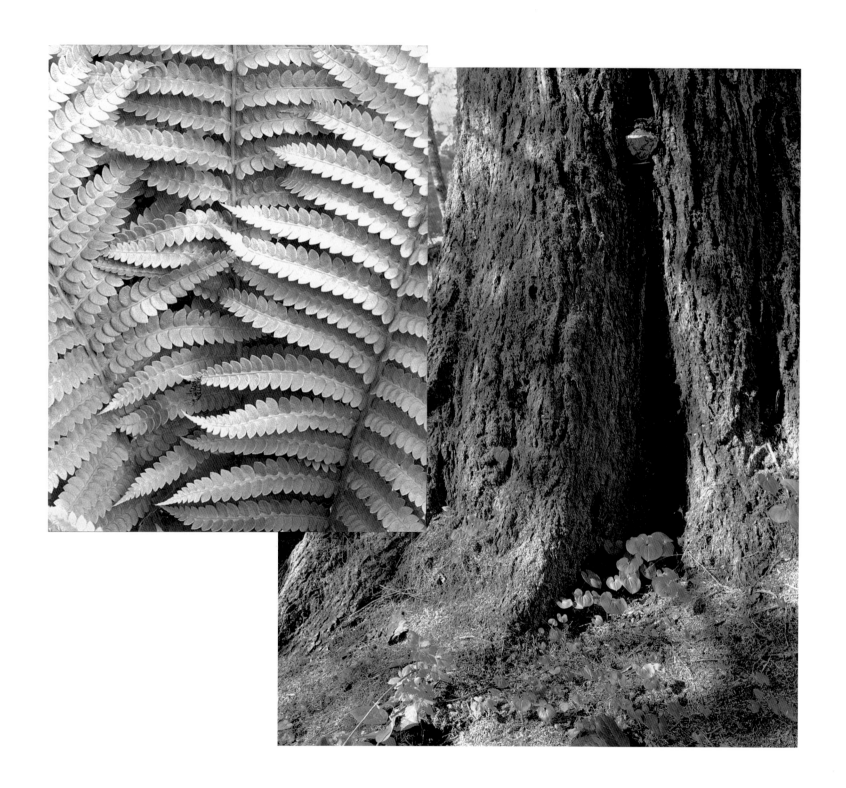

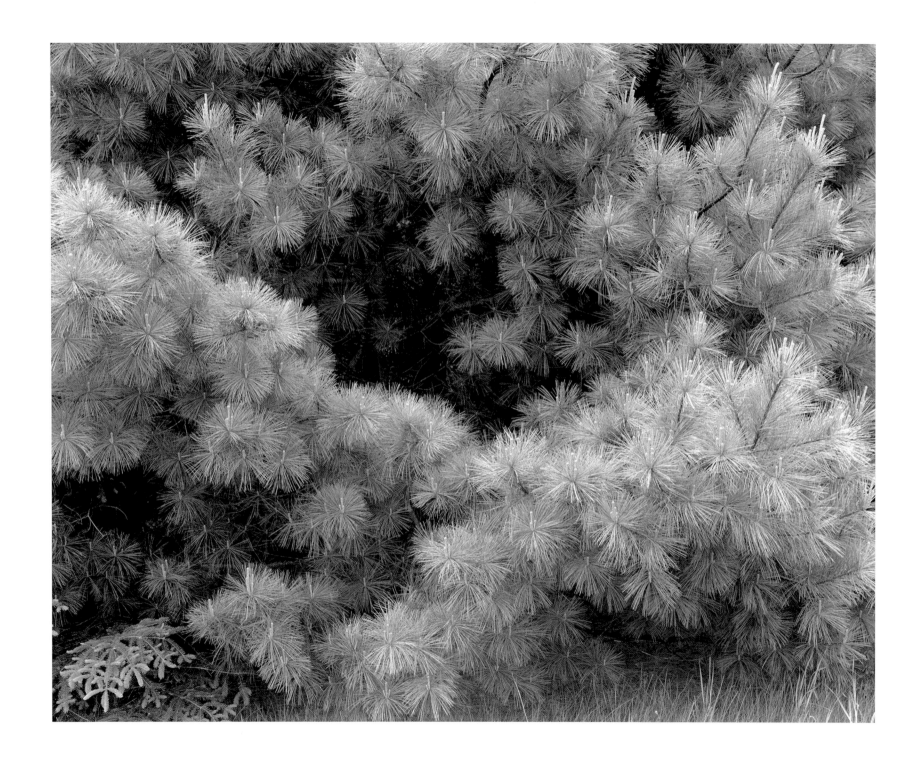

59

Plants go well beyond production of energy-rich molecules of food. They create diverse designs, from the spirals forming conifers and club mosses to the branching planes of elms and sarsaparilla and the orbs of blueberries and doll's eyes. From these creations, vegetation drapes cloth over our landscapes in powerful patterns.

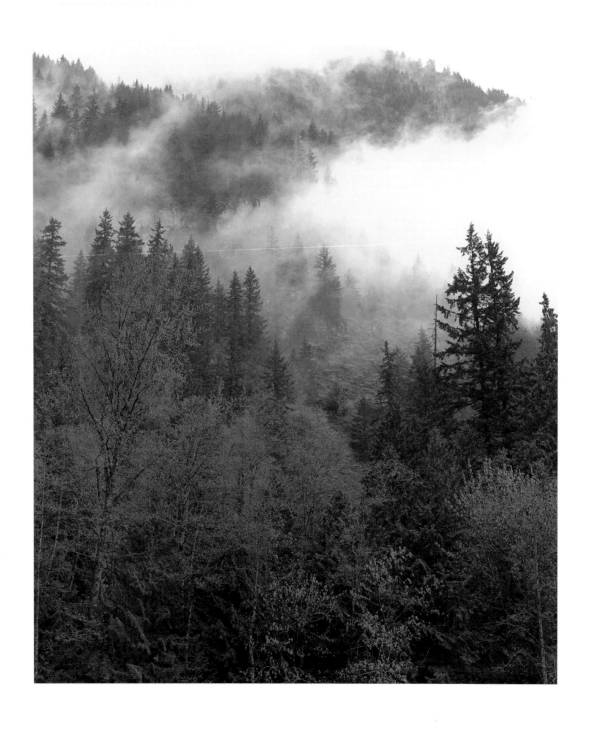

Plants, both living and dead, exert strong forces on the land. They split rocks, evaporate tonnes of water, and hold the soil against strong physical forces. Plants build places for other life-forms. And they calm other forces, such as wind and frost. They give predictability and time for adjustment to other living things — and to us.

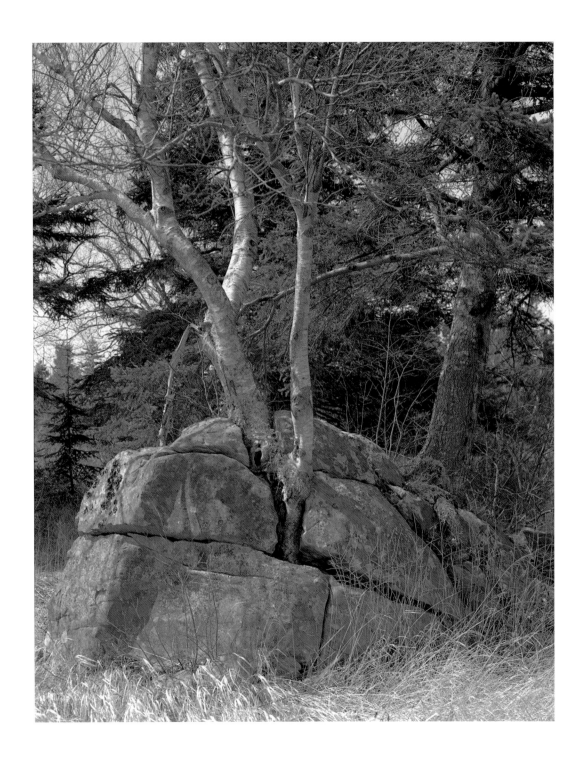

Moose meadow indeed. The circumpolar boreal forest soon will contain more carbon stored in its litter and undecayed organic matter than will remain in the tropical forests. Tropical forests store carbon above ground in the trees which we remove and they store virtually none in litter or soil. Boreal forest does not grow trees so well but it does not decay the accumulated organic matter in the litter that we have not removed. So the boreal is becoming the prime living storage depot that keeps carbon out of the atmosphere.

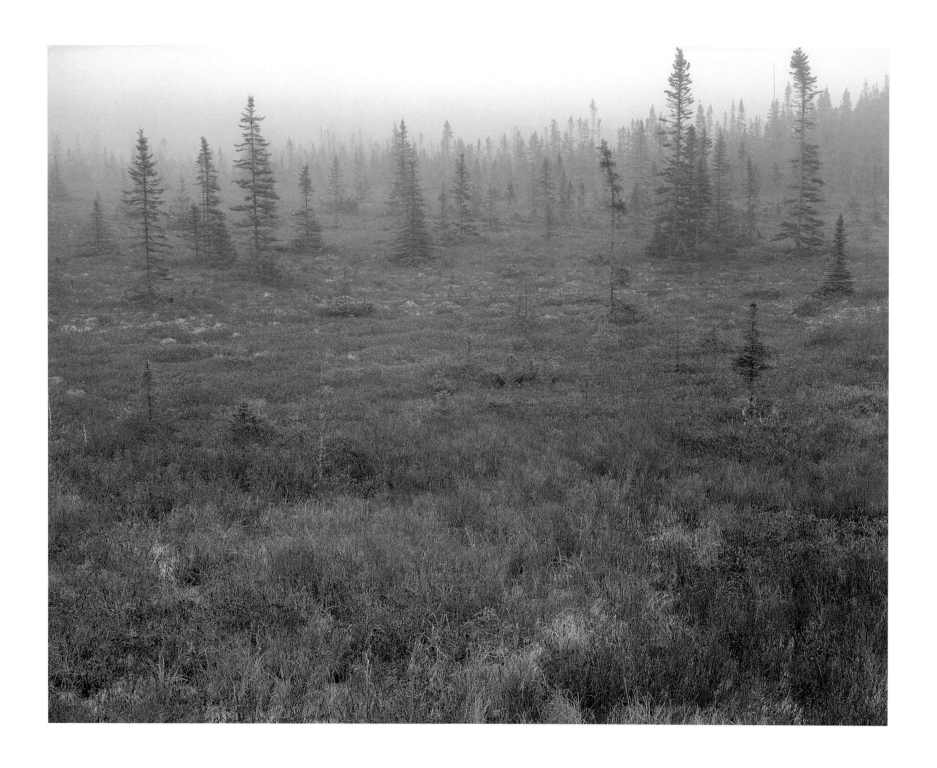

The forest canopy reaches above our normal viewpoint. To some, raised on the plains, this may seem overpowering and stifling. With a different perspective, others see the forest as a big warm blanket, comforting and protecting. Whatever the vegetation that has influenced our perspective, we all need to see the aesthetic delights flowing from it.

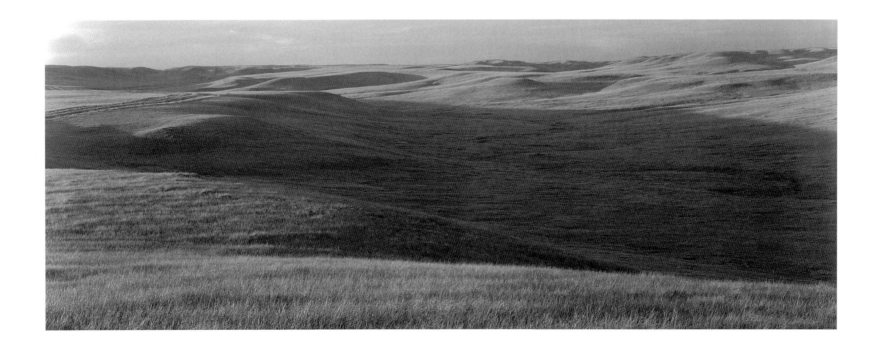

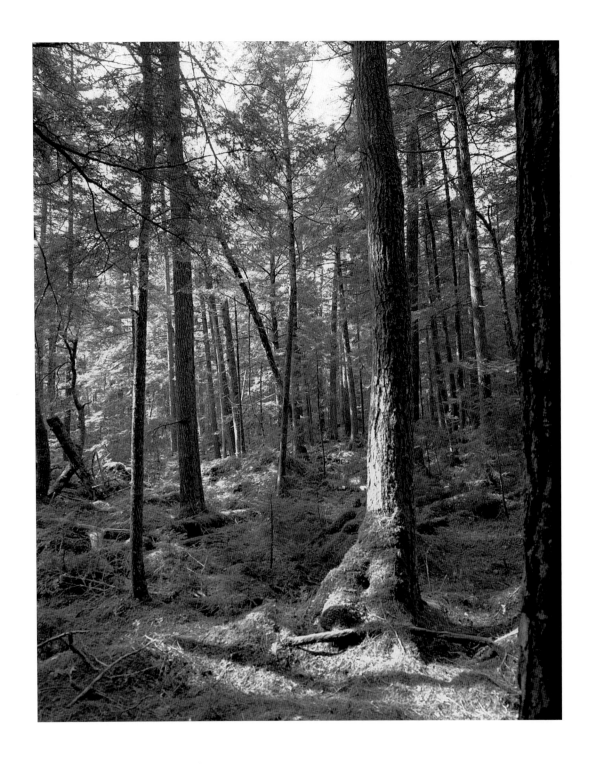

For those with spirits rooted in the forest, it now is possible to rise into the canopy and explore from a new perspective. Canopy walks are available in Canada, here in the Haliburton Forest, and in Australia and South America. Take a walk.

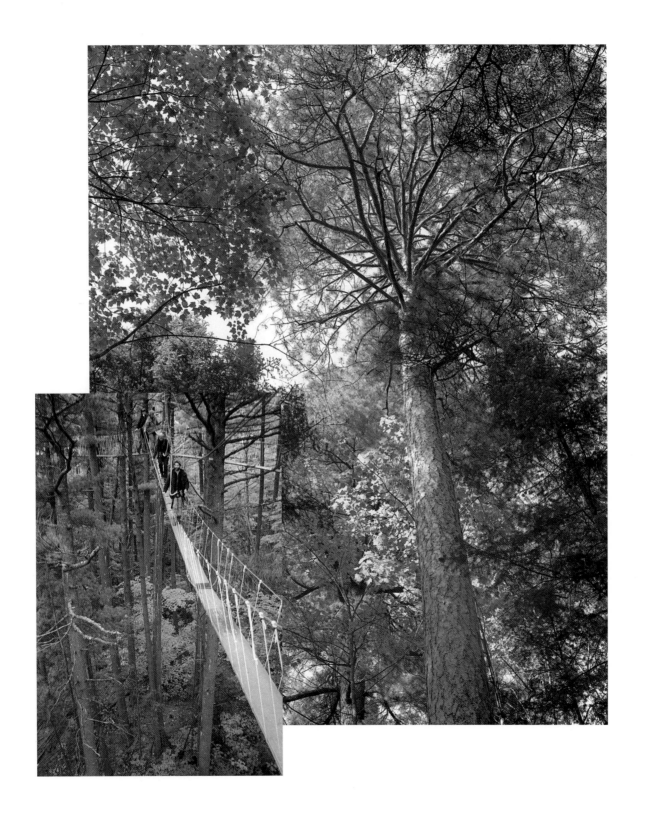

RESTOCKING

decomposition and nutrient recycling

LIKE ANY MANUFACTURING PROCESS, storage of solar energy in plant tissues by green magic would stop without a continuous supply of raw materials. Nutrients for plant growth must be continually restocked where the plants' roots can get them. In the same way, continuing to feed the family requires restocking the food in the home kitchen cupboards. The important difference in restocking for green magic is that many of the nutrients are restocked by recycling, and the ecological system itself does all the work of restocking without outside help, except from the atmosphere.

Without decomposition of dead tissues of other organisms, the availability of nutrients for plants would be limited. Nutrients would become available to plants only as fast as they could be released by the slow breakdown of rocks. That flow of nutrients newly released from the rocks would be very small compared to the flow of nutrients from decomposing tissues of organisms, and plant growth would be slowed down. The reduction in food production by green plants would be great, and many species of animals would be lost from the biodiversity of an ecosystem. More energy and more matter is processed by decomposition than by any other process except the green magic of primary production. Cycling of matter through decomposition is critical to the self-maintenance of ecosystems.

Composting is a natural maintenance process. All living things contribute their matter to the decomposition process. Decomposers do not eat only dead carnivores. They work all along the food chain, eating everything from leaves and bud scales of plants to rich droppings from herbivores, whether moose or caterpillars, to old dead wolverines. Decomposers get big feasts from dead animals. Of course, the dead herbivores and carnivores and all their dung and other bits all originated as plant matter that was transferred along the food chain. But many plants contribute used, dead parts throughout their lifetime. Flowers and leaves of spring flowers return their nutrients to the soil quickly after they blossom; a wild leek turns to mush in just days. Trees drop their flowers, bud scales and leaves many times before the tree itself dies. Snag trees in the forest are just early stages in decomposition. When they fall, they become 'big litter' on the forest floor. Then decomposition becomes much more effective when decomposers from the forest floor can more easily invade the tree trunk.

Even wood, with its tough cellulose fibres and lignin glues, is decomposed over a few seasons. After the less well-equipped decomposers have stripped the soft tissue from under the bark, boring and chewing decomposers such as wood-boring beetles open tunnels into the wood. Boring beetles carry other decomposers, such as many fungi, into the core of the wood and many more decomposers make their own way in along beetle tunnels. As this 'big litter' has rents and cavities opened in it and becomes inhabited by a vast assortment of decomposers, their predators are attracted too. Later stages of decomposition make survivable environments for many species, even for larger predators such as salamanders, frogs, and snakes. Dead trees on the forest floor are anything but 'waste.' They are returning nutrients for other plants to use, and they are vital to the diversity of habitats. The survival

of a very large fraction of the biodiversity of the whole ecosystem depends on decomposition. A neat forest floor is a poorer place.

Nutrient matter and trace elements are recycled to the plants, but there are other products, too. Some components of organic matter are very resistant to decomposition, and stay in the soil as humus for very long times. Humus and earlier fibrous decay stages of organic matter add special qualities to soil. Fibrous material helps form granular structure in the soil. This partly decomposed organic matter also affects soil chemistry. The surfaces of well-decomposed organic surfaces are colloidal — made up of very small particles. Colloidal organic matter has very high capacities for holding both water and nutrient particles — nutrient ions. Plants can trade hydrogen ions exuded from their roots for these vital nutrient ions, such as potassium and calcium. Until the plants can take up the nutrients, the organic matter produced by decomposition attracts and holds these ions where the roots can reach them. This optimizes the uptake of nutrients by the plants, because they send for nutrients only when growth demands them. Holding of nutrients by the decaying organic matter also prevents removal of the nutrients down through the soil by percolating water. So, while soil organic matter is releasing its own nutrients, it also functions as a nutrient trap that releases ions as they are needed by plant growth; a fundamental process in preventing 'leaky' ecosystems. Self-maintenance at its best!

Decomposition involves different groups of decomposers, different chemistry, and different processing speeds, depending on the type of plant material being broken down, and the chemistry of the soil and water. In some crop fields decomposition goes too fast and too far, leaving very little organic matter in the soil. Uncultivated prairie grasslands stored a large proportion of their primary production as organic matter in the soil. Before plowing, prairie soils had four to six feet of rich black soil.

Black organic matter in prairie soils was mainly the partially decomposed roots of grass. Cultivation moved that organic matter to the surface and repeatedly exposed it to the air, increasing its rate of decomposition. The black soil layers decreased by half in about fifty years after we 'broke' the land by plowing. The disappearance of black topsoil and the 'browning' of eastern farm soils involved the same process.

The Sparrow Report of the Senate of Canada reported in 1984 that prairie soils have lost nearly 45 percent of their original organic matter since cultivation began about 1900. In Ontario and Quebec soil organic matter has declined by as much as 50 percent since first measured.

Under deciduous forest, such as the maple-beech woods of Great Lakes farmland, decomposition is more constrained and can incorporate enough humus and other organic matter into the upper soil to create a very rich layer of black-brown soil. Under the boreal-spruce-fir forest of Canada's north, the needles and bark from the conifers, together with the acidic nature of the soil and a short warm season, cause a very different pattern of decomposition. Fungi replace bacteria as the main final agents of decomposition, and much of the forest's litter does not fully decompose. Hence the boreal forest commonly builds a thick blanket of partially decomposed litter.

This thick layer of partly decomposed litter is a storage depot for global carbon. Even though the amount of wood above ground is not large, the boreal forest is a major storehouse for carbon. The spruce and fir take carbon dioxide from the air and build plant tissue with it. Much of that plant tissue decomposes only partially and very slowly so the carbon in it is kept from returning to the atmosphere as carbon dioxide. Historically, the world had large storage depots of undecomposed plant tissue that naturally protected against global warming. In the tropical forests, where leaf litter decomposes quickly and totally, there was no carbon storage in the litter, but much in the wood of the trees. In the north, where

less wood grows in a season, the storage was in litter on the forest floor, because it decomposed very little and very slowly. However, we are releasing the carbon from all types of forests by clearing and burning. Industries, such as Ontario Power Generation, now are starting to copy the process of carbon storage used by forests in a variety of 'carbon sequestration' initiatives that aim to offset their contributions to the rate of increase of the carbon dioxide causing global warming.

Decomposition is even slower in peat bogs and muskegs. Classic peat bogs have no soil made of inorganic minerals like sand and clay. Their living plants are perched on a huge pile of undecomposed plant material — a dome of peat. Peat in sphagnum bogs is sphagnum moss just starting to decompose. Only the outer surfaces of the moss are decomposed—and these to a stage that forms very small particles. This colloidal material is able to trap alkaline ions from the bog water, preventing them from neutralizing the weak organic acids produced by the peat. Consequently, those normally weak acids are able to produce unusually high acidities — as acidic as pH = 3.5. This acidity prevents bacterial life and so the peat does not decompose — in effect it is 'pickled.' In fact sphagnum peat is so sterile that it has been used in wound dressings in wartime. That same sterility and lack of decomposition accounts for the remarkable preservation of human bodies that have been found intact even after hundreds of years buried in Jutland's peat bogs. Here again, in peat bogs and muskegs, millions of tonnes of carbon are sequestered from the earth's atmosphere until we drain the bogs or dig them up, drying the peat and causing it to oxidize. We have mined peat throughout history. Much peat from the Netherlands was the fuel that supported the Dutch empire during its dominance. Peat is still unearthed but much less than in the past. Canada's Hudson Bay Lowlands contain a globally important store of peat in the muskegs we often call 'moose pasture.' Disparaging muskeg and other natural features associated with carbon storage and decom-

position reflects our lack of familiarity with the processes of the carbon cycle and its immense global ecological values.

It may even be that the process of decomposition and recycling can help us learn to think realistically about the notion of sustainability. The amount of plant matter that can be produced from green magic is limited by availability of nutrients. Nutrients recycled by decomposition are enough to replace only the amount of plant matter that is being decomposed. But we harvest much more in addition and remove it. When we harvest, we are removing plant products, containing their nutrients, from the site.

The conifer forests of central Nova Scotia yielded one-third more fibre when trunks and branches were taken compared to conventional harvesting of trunks only. But the amounts of five nutrients that were removed in the harvest almost doubled.

If we want to sustain the nutrient availability on a site, there is a limit to how much we can harvest. If the vegetation harvested contains more nutrients than are added from the rocks, soil, and decomposition, we will deplete the nutrient supply. To take more in our harvest requires that nutrients be added from another source if the harvest is to be sustained. This is what farmers do. They replace the nutrients removed in the harvest by bringing in fertilizers. Because most commercial fertilizers lack organic matter, their nutrient chemicals must either be taken up quickly by the plants or they are likely to leak out of the soil and 'eutrophy' (over-fertilize) local waters.

When the plant cover was removed as was done in an experimental clearcut of hardwood forest, the outflow of nutrients eutrophied the stream draining the forest Nitrogen outflow increased almost 100-fold, Calcium 10-fold and Potassium 20-fold.

Forestry seldom uses fertilizers except in plantation forests and industrial forestry. Instead, growth depends on recycled nutrients from decomposition, plus nutrients newly released from the rock and soil. Forests that maintain themselves by natural processes, including decomposition, are sustainable whether harvested or not.

We should be determining our 'sustainable' harvest with nutrient stocks in mind. But it seems that we commonly harvest from natural systems without decomposition in mind. If we remove nutrients faster than they can be restocked, we will not just empty the cupboard. We also will eat into our natural capital, because we will prevent the maintenance of the machinery needed to keep the green magic factory running. Is conversion of larger areas of natural systems to food farms and to fertilized tree farms an acceptable option? Will it last?

It is clear that somehow the nutrient supply in every particular place must be restocked if the ecosystem in that place is to continue to maintain itself and its natural processes. The process of decomposition, and human interactions with it, are major forces affecting the sustainability of this nutrient supply that is vital to self-maintenance.

Nature's compost barrel overflows — if we just let it. Contrary to the views of the hygienic forester and the neat gardener, dead, used plant products should lie around in the ecosystem that produced them. Nutrient recycling in that ecosystem depends on it. What is the origin of the human tendency to be a neatnik? Uncertainty based on poor knowledge? Blind acceptance of commercialized cultural trends?

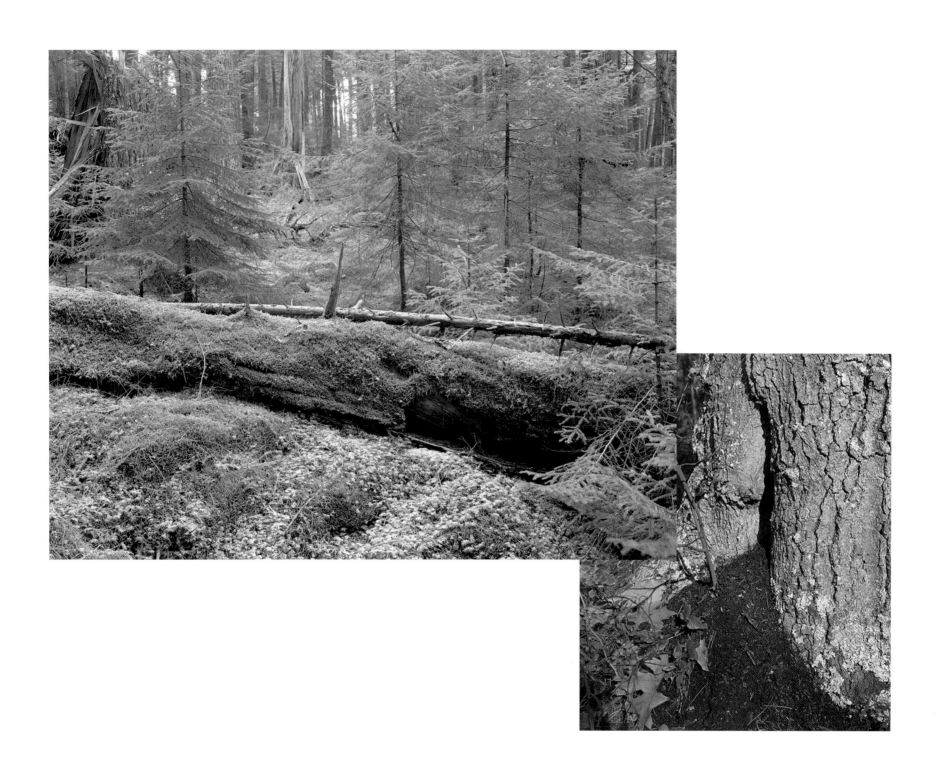

It is called 'litter' but it might better be called 'riches,' or part of 'natural capital.' Litter is a base for the economy of an ecosystem. There is a sustaining capital base with an inflow of dead and used parts from all organisms in the habitat, plus those visiting from elsewhere. The outflow goes to all living things in the habitat in which the litter decomposes. An intact ecosystem prevents leaks of those recycled nutrients — part of the system's vital riches. Opposing the strong forces moving matter from the land to the oceans is a major self-maintenance process executed by functional ecosystems. Many humans target the opposite — remove the litter and hurry the runoff.

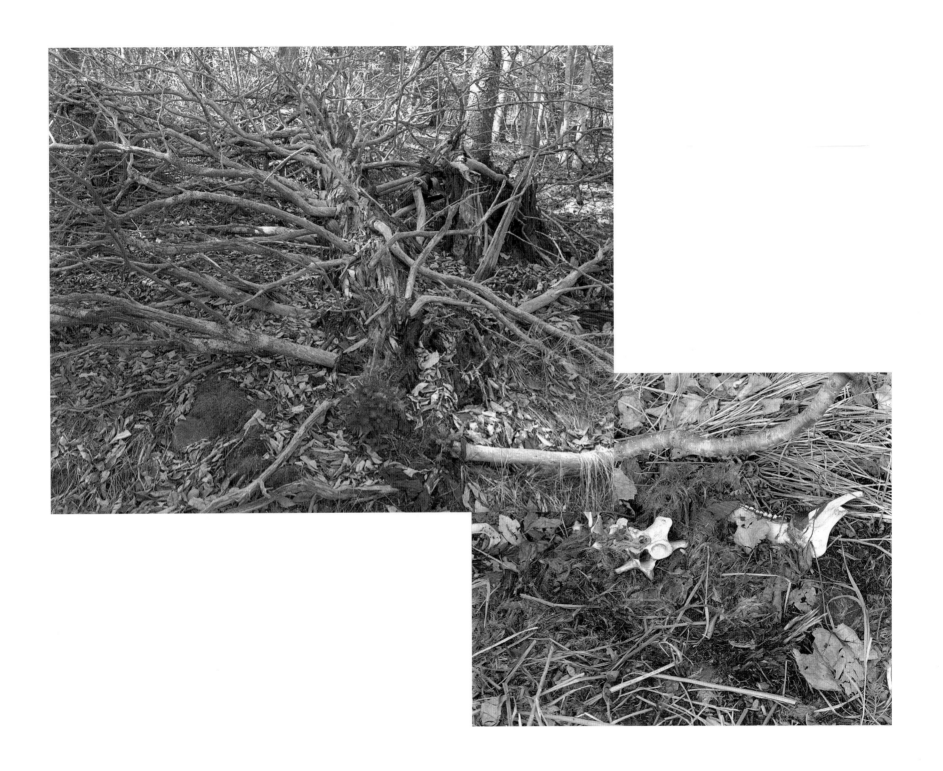

Feeding by herbivores such as deer and caterpillars keeps plants from hoarding all the nutrients in the ecosystem by rerouting the flow of food into their own herbivore tissue. But tissue eaten from one plant also renews plant growth somewhere else — where the deer drops its dung and the decomposers make it available again for plant growth.

We may regret the death of an animal because of the marvellous stimuli it gave us when alive, but the role of those vital behaviours are replaced by other values after death. Besides the vital stimulating characteristics that we associate with a deer or a trillium, they also have characteristics as biomass. Possibly the longest term criterion of success for a population of plants or animals is their accumulation of biomass, concentrated from nutrients and processes dispersed widely throughout the landscape, and organized and grown, according to their particular genetic instructions, into their biomass. But it is just moving through. If the genes and the processes remain — it will continue.

Dead bodies may be a small fraction of decomposers' fare. They don't live off one end of the food chain; they dine on parts of plants and animals discarded throughout their lives and all along the food chain — flower petals, acorn husks emptied by squirrels, chrysalis cases of monarchs. As soon as you think about decomposers, food chains become food webs — both because decomposers are all along the food flow path and because decomposers are actually a highly diverse cadre of organisms. Perhaps a falsely exclusive group — if a maggot is a decomposer, why not an otter?

Stages in decomposition of one organism are habitats for others. The slow decomposition of woody tissue provides habitat for many species as the live tree did — just a different group. Ants, bark beetles, woodpeckers, fungi would all lack habitat without the 'snags' in a forest before they fall to continue the process on the forest floor. Removal of all dead wood from a forest is a form of biocide.

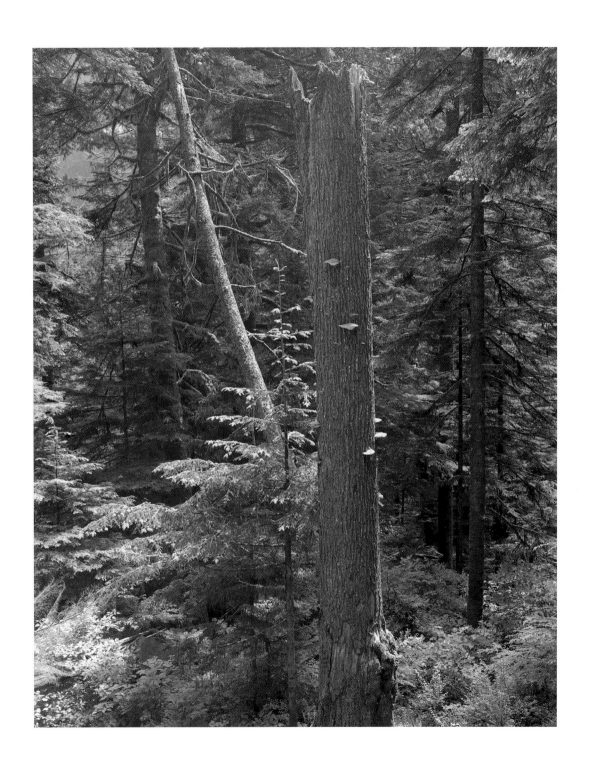

A log's contact with the forest floor brings on teams of decomposers sequenced according to difficulty of entry into a log and difficulty of digesting the log's riches. Soluble starches and sugars under the bark go first. Then species able to bore into wood open the way for many species. Enzymes able to digest cellulose or lignin are invaluable but uncommon adaptations. But logs do return to the soil.

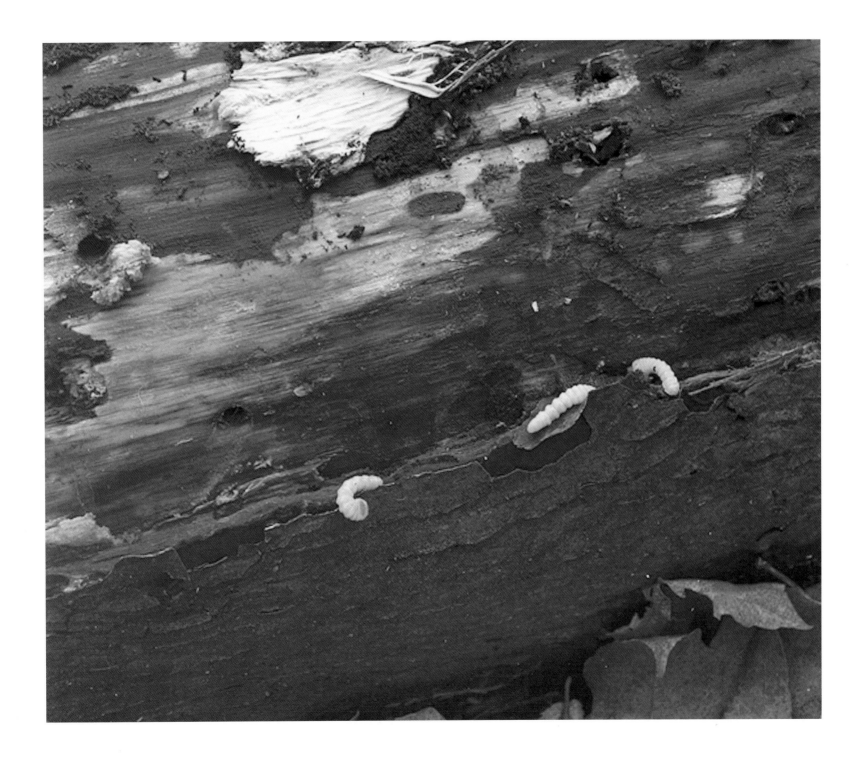

Decomposers have habitat requirements too. Too cold, too little oxygen (air), too acid and decomposition slows enough that organic matter from dead plants builds up. In acid bogs, such as the Mer Bleue near Ottawa, decomposition is negligible where the bog is undisturbed. The appearance of a dome in the centre of the bog is due to build-up of undecomposed plant matter, largely dead Sphagnum moss. Invasion by beavers over several decades dammed the outflow from the bog. This has caused nutrient build-up, increased the decomposition rate, and resulted in major changes in the vegetation. Changes in decomposition processes in the bog could change the bog to another ecosystem type.

To increase agricultural production in the short term farmers attempt to prevent anything except the crop plants from using the resources of their fields. If intensive harvesting is combined with this process, little organic matter may be left in the fields, and decomposers may be unable to recycle much of the nutrient supply needed by the next crop. Importation of fertilizer is the usual solution. If the fertilizer is synthetic, soil organic matter may remain a problem. All of these functions are taken care of by natural processes in wild systems.

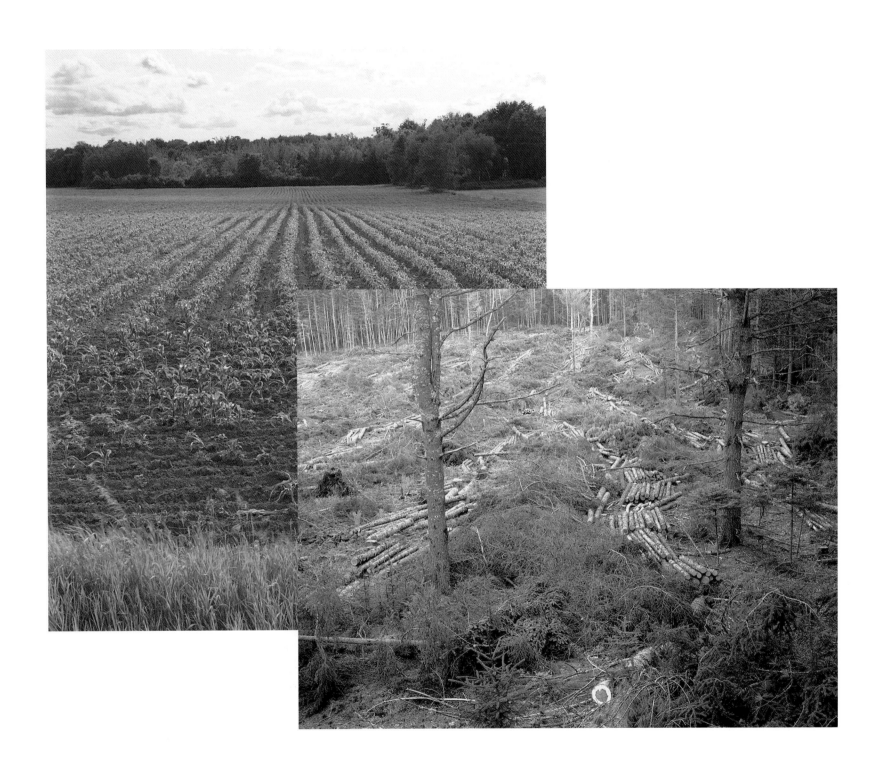

Forests that maintain themselves by natural processes are sustainable. The value of a heritage in sustainable ecosystems can be seen in Jim and Margaret Drescher's harvested and managed woods near New Germany, Nova Scotia. Food energy, nutrient flows, all the life forms of plants and animals, and aesthetic delights for the human spirit are inheritable natural capital.

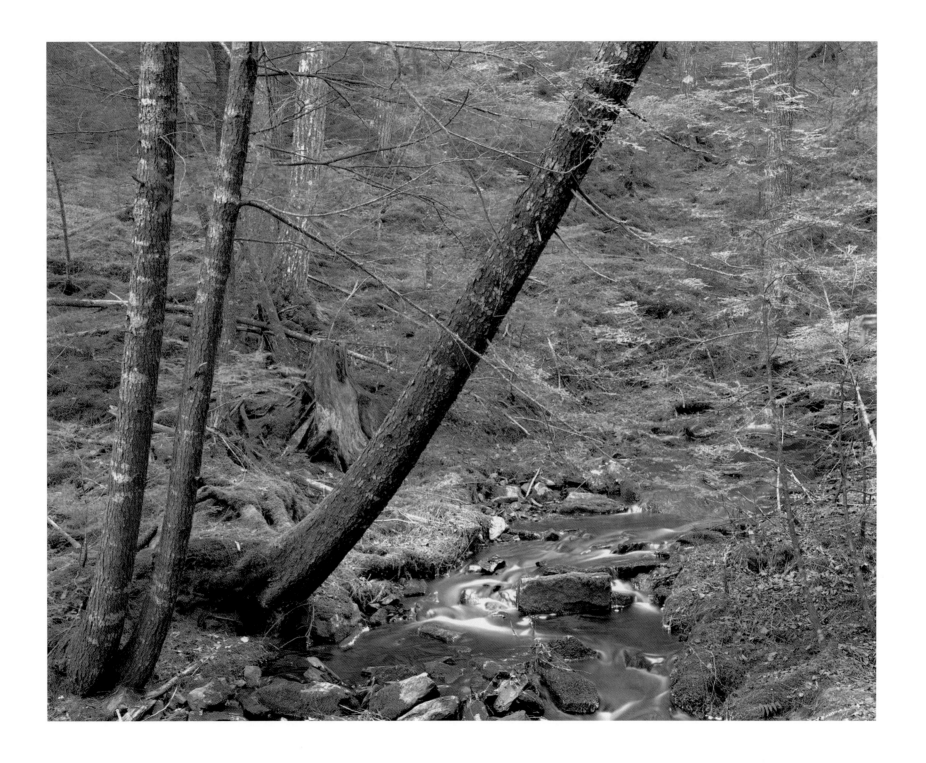

A PLACE TO LIVE

habitat

IMAGINE THE MINERAL SOIL — the angular, fractured fragments of rock called till — emerging from under the retreating icy toe of a glacier. Many of our habitats started there. At first, topography of the piles of till dropped by the melting ice prescribed wet and dry habitats and, together with the quality of the glacial 'soil,' determined where different plants would grow. So the first forces shaping habitats were the non-living processes of chemistry and physics overlaid with an increasing complex of life processes. The non-living substrate — the till — was a patchwork of variable qualities: texture, drainability, nutrient content, acidity.

'New' habitat, freshly formed and without any influence from the biota, can still be viewed at the melting toe of the Columbia Ice Field, in Jasper National Park, where it gives rise to the Sunwapta branch of the Athabaska River, or in Kluane National Park where the Kaskawulsh Glacier drops its load of till as it melts into the Slims River.

The life forms managing to survive on that purely physical substrate also formed a patchwork, not only of differing species, but also of their powers to change the non-living environment. Arriving animals had to choose a type of patch or a set of patches to attempt their colonization. Soon, the animal patchwork also became a force in the processes defining habitats. It is no different now — although possibly more complex than just below the toe of a glacier. Habitats are shaped by a multiplicity of forces, both non-living and living.

Habitat is meaningful only in terms of particular species or groups; it is where a particular plant or animal lives. Species vary from extremely specialized in their habitat choice to very non-selective. Habitat can be very limited for specialists such as some parasites, or can be freely available for generalists such as raccoons, robins, or humans. Even within a species, needs change with life stages and either the habitat must fill those changing needs or the species must choose a different habitat to suit the stage. Some ducklings demand only invertebrates but change to eating plants when adults. Habitat for larval black flies is fast water, where they can filter food particles flowing past, but adults choose air in which to bite us. Dragonflies have a similar dual habitat but spare us the bites. Larval and pupal and adult butterflies need three different habitats. Frogs and toads may require separate habitats for overwintering, for mating, and for foraging in late summer.

> Tree frogs overwinter on land. In early spring they move to the water for mating. Adults leave the water and climb into shrubbery and up trees, where they feed and call, sometimes being mistaken for birds. About seven weeks after hatching, the young also leave the water, and feed on land until autumn. The habitat of frogs is not just 'water,' or even 'wetlands'; it is everything they need to complete their life cycle and to reproduce.

Habitat requirements vary among amphibian species according to vast differences in physiological adaptations. Some overwinter carefully in the bottom of a pond, others, such as wood

frogs, are able to tolerate whole-body freezing and just tough it out under a rock.

Considering variation in habitat choice is important to understanding relationships of species to the landscape. In fragmented forests, some birds are 'forest interior species,' which nest successfully only in the special habitat of a forest interior. But there also are forest bird species that nest in either forest interior or in forest edge habitats. Then, because the edges of forest fragments border open land or farmland, there are species that come from that open land and nest in the forest edge. These are species that fill some of their needs such as food from open land but use forest edge as nesting habitat. This is a common pattern of using two or more habitat types across an edge to assemble a complete set of resources. Consequently, edges are rich in both species and numbers. People hunt along edges. And so do foxes and other predators.

Even species with narrow habitat choice, such as forest interior birds, have much broader habitat needs when we consider their entire life history. When they first take wing in late summer, fledglings of forest interior species must feed voraciously to prepare for fall migration. They forage across the landscape and in so doing, they become familiar with forest fragments other than the one where they hatched. This may result in yearlings returning from migration to woods other than their natal patch. Thus habitat patches that have lost a species may be recolonized by the species that they have lost. The full breadth of habitat variability is evident in migratory species, some of which alternate between herbivory and insect eating as they move between the temperate and tropical ends of their annual life history. It is unusual, in our habitats, for a species to need only one special set of resources, all found in one place. It's probably a parasite. Rather we might expect species to fill their changing set of needs where those resources can be accessed successfully during successive life stages.

The magnificent Pileated Woodpecker illustrates the kinds of adaptations to habitat change that may allow the species survive in landscapes that are being changed by human activities. A few decades ago authoritative texts designated the pileated as a species of extensive wild forests. It was said to require a minimum habitat unit of not less than 70 hectares — nearly 200 acres of forest. Then Dutch elm disease devastated the stately elms of our farmland. Thus were created lines of dead and decaying elms along fencerows in farmland between the fragmented farm woodlots. Pileated Woodpeckers from larger forest patches investigated these dead elm resource patches and began to follow their lines across the landscape, discovering little habitat nodes along the lines — the farm woodlots. Eventually some Pileated Woodpeckers nested successfully in woodlots too small to provide food for their clutch of young. 'Trapline' foraging behaviour developed that moved them past enough dead elms in fencerows and into enough small woodlots to knit together enough support for marginal reproduction. Adaptability in habitat use may allow some species an uncertain level of presence in our environment. But presence should not be confused with population viability.

Snapping turtles have suffered some habitat loss, but perhaps other modifications of their habitats have interacted with their reproductive life history to have more important effects. Snapping turtle populations have an uncertain future. They reach reproductive maturity slowly, deliver no parental care to a clutch of two dozen eggs and even fewer hatchlings. So they depend on a very long lifespan to be able to replace their population numbers — something over 25 years average longevity of females. Human impacts on their habitat, and on their mortality rates, and on their success in reproduction combine to make sad predictions for the future of this ancient and wondrous reptile. Nest sites for snappers used to be sandy shorelines of lakes and rivers. We built on many of these. Worse, we built roads along them, and the well-drained gravelly beds brought in for the roads, especially south-facing

shoulders, looked to female turtles like nest sites. Road building also restricted drainage, and formed ponds near roadsides. Female turtles adapted to these massive changes to the landscape by trying to lay eggs in road shoulders. Females are hit by cars, coming and going. Females are ensnared by six-pack plastic. Hatchlings are hit by cars. Turtles try to live in roadside pondings, so the distribution of turtles becomes more aligned with the hazard. The range of surviving turtle populations is mainly in 'cottage country' and large recreational parks and forest lands. As tourist and logging truck traffic increases, turtle longevity declines. And without an expensive response, snappers may be lost because of a combination of these habitat changes and the turtles' deadly adaptations to them.

Because different habitat patches have different capabilities for green magic and all the secondary products that flow from it, there are patches of high and of low resource richness across the landscape.

> A hectare of young aspen may make up to 17 tonnes of food per year available to herbivores, but an older patch of aspen next to it may supply only 3 tonnes and a fully mature patch of hardwoods, such as oak or maple and beech, may have no food for herbivores left over after the forest meets its own needs for food and maintenance. Neighbouring patches of farm crops or of reedy swamps may be several times richer as sources of food.

It is not possible to place a resource-rich patch next to a resource-poor patch without causing a flow of resources from rich to poor. A habitat patch with large amounts of net primary production — left over after the plants take their share — will attract grazers and browsers from other patches. Deer will feed in a productive wetland and take their harvest back to an upland woods to chew their cud, deposit nutrients, and hide in the dry

cover of the forest. By such exchanges, a mosaic of habitat patches will become linked into a landscape-scale functional whole — an ecological system.

Habitat can be accessed more easily if a species is able to move without risk through intervening non-habitat. But many kinds of non-habitat can be dangerous or threatening enough to prevent passage. Many human activities, such as farming, cut through the natural pattern of habitats breaking it into small patches or fragments. Fragmentation of habitat by natural or technical means can isolate a species into small patchy populations that cannot exchange individuals for breeding or for replacement of losses.

Similar problems have to be solved by individuals of species that form their habitat by using an array of patches of different habitats scattered in the landscape. Even in primitive wilderness some species have linked an array of patches within the primeval landscape into a multifaceted habitat. And the spatial arrangement of habitats changes over time. All species have a seasonally changing sequence of needs that must be filled from resources in their habitat.

The Porcupine caribou herd travels every spring to its calving ground on the shores of the Beaufort Sea between the mouth of the Mackenzie and Prudhoe Bay. Each autumn they travel over 1000 kilometres south through the Brooks Range and British and Davidson Mountains, past Old Crow, onto the Porcupine Plateau, and on into the Richardson and Ogilvie Mountains as far south as Dawson. Every year they travel thousands of kilometres to fill their seasonal array of needs. Earthworms may manage it within a cubic metre.

Human disturbance increases both the fragmentation of habitats and their isolation by placing barriers between the habitat patches. Many species in settled areas gradually disappear from a region because they cannot access habitat patches to fill all the needs on their seasonal list. Filling our needs by shopping is very similar. Unless you have access to a good general store, on

any shopping trip you must visit several different sources to find all your needs. They may come from scattered separate stores or from a cluster in a mall. As seasons change you will have different needs that make you visit a changing set of stores to fill your seasonal needs.

 Imagine circumstances that increasingly separate the stores and imagine you have to dodge severe hazards, such as heavy truck traffic, getting among them. Imagine adding a wall of concrete, like the ones used to separate traffic lanes on highways.

For theorists, it is a problem of a dynamical system of needs driven by life history features that can only be filled by solving a set of dynamical equations that specify where the resources to fill those needs are located at the specified time. It is amazing that so many species manage it and even more amazing that they survive the disturbances we have put into the resource and environment systems.

Two dimensional spatial habitat patterns are a simplification. Exploration of the trunks and canopy of a deciduous forest will quickly convince us that the third dimension is needed for understanding. The same is true if we look down into the soil, down through the winter snow, and down through the water column of a lake, or a bed of aquatic plants in a river's edge. Every habitat is also topped by a column of air linking it to the atmosphere. Many of the natural processes leading to survival cannot be fully appreciated without three dimensions of space plus the dimension of time. All these dimensions can be viewed at more than one scale. There is a range of scales from the size of a den or burrow up to the scale of an annual 4000 kilometre migration that must be considered because questions asked at the scale of a centimetre will give answers that do not necessarily apply at a scale of a kilometre.

Habitats are not simple — especially when our actions modify environments and when species adapt to survive. The assembly of many habitats into a system allowing a multitude of species to survive in the same environment is wondrous. Although we have yet to apply our full capability to it, our attempts to repair and maintain semi-natural ecological systems have been primitive. Even with our advancing abilities in information transfer and system design, the integration of such a complex is surely beyond us. We seem unable even to meet Leopold's First Law of Tinkering[1] — 'keep all the pieces' — let alone go beyond it to fabricate new assemblies. Perhaps we need to focus on fitting ourselves in, with less disturbance and fewer losses of the original pieces.

1 Aldo Leopold. 1949. *A Sand County Almanac*. Oxford University Press.

Primeval habitat. As the glacier retreated it uncovered and formed habitats which were abiotic — without influence of living things. Habitat variations were simply physical and chemical — topography, drainage, mineral type. This was the primary heterogeneity — the variations across the landscape. Ten thousand years later, differences among habitats are dominated by the effects of living things on the underlying abiotic differences. This secondary biotic heterogeneity dominates the diversification of habitats, thus the biodiversity of the land.

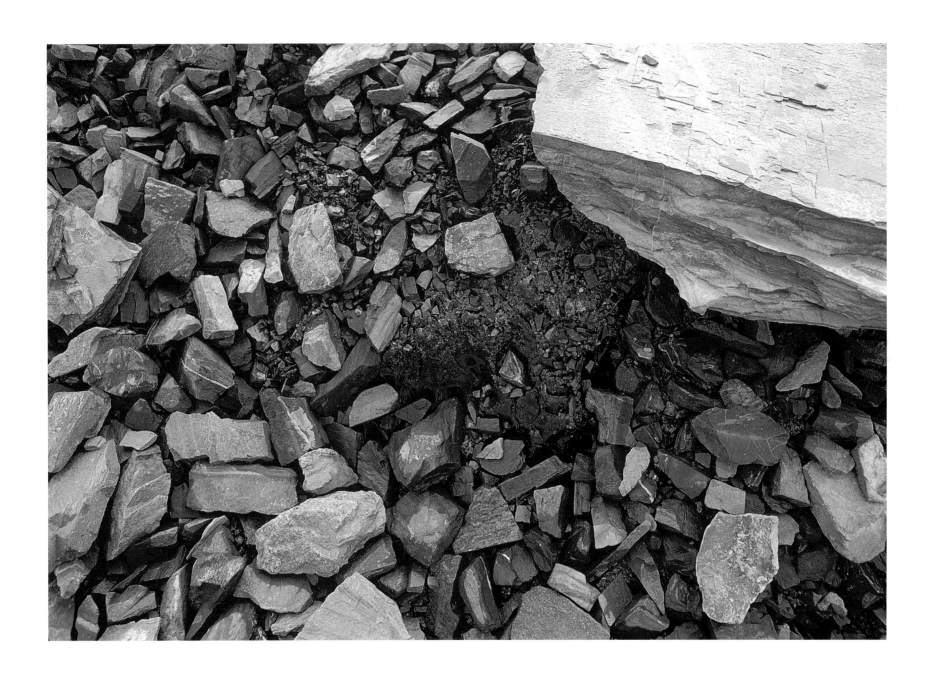

Living things do not just accept or reject a habitat. They try to survive in a chosen habitat by modifying it to meet their needs. Here, on very ancient Precambrian rock at Blachford Lake, NT, the lichens were able to fasten to the rock and take all their needs from the air and rain. The lichen growth trapped blowing organic debris and together with their own organic matter this made a habitat that mosses could tolerate. Mosses, in turn, will change the environment until it is survivable habitat for sedges. The changes from bare Precambrian rock to sedge habitat are immense in terms of the biodiversity that can be supported.

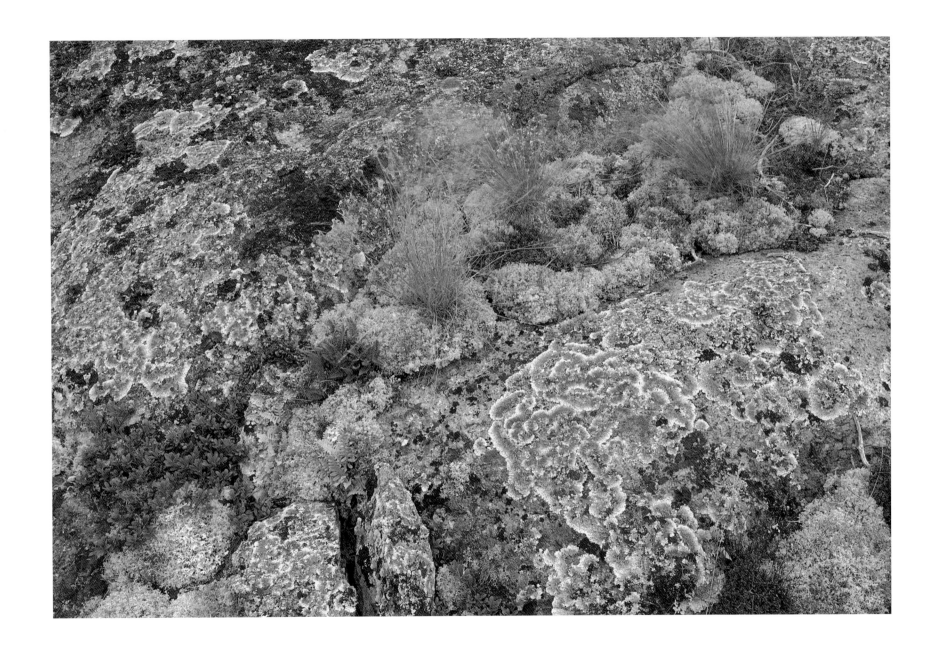

Fast water is habitat for Nova Scotia's larval black flies. But that is only part of the story. A different habitat is needed by the adults. And other black flies in other lands prefer slow-water ditches. Habitat for a song bird is not well-characterized just by where it nests. Fledglings may need other habitats to feed in before migration. And on the wintering grounds, they use an entirely different habitat and possibly a very different food type. Habitat must enable the entire way of life of a species both in time and in space. Habitat varies from species to species. But habitats are not mutually exclusive — a number of species overlap in any habitat patch. Preservation of individual habitat patches is not sufficient for species conservation.

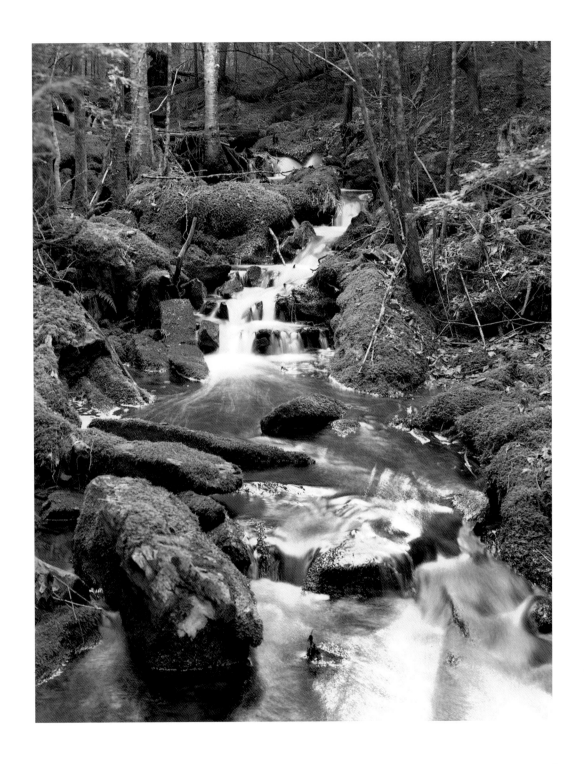

To some, 'edge habitats' are less than pure. Continuous primeval forests were a mosaic of habitat types. Enhancing the available diversity of resources by using both sides of an edge probably has always been an important way to use habitat. Human-made edges have different qualities than edges in a forest mosaic, and can change species distributions, habitat choices, and survival.

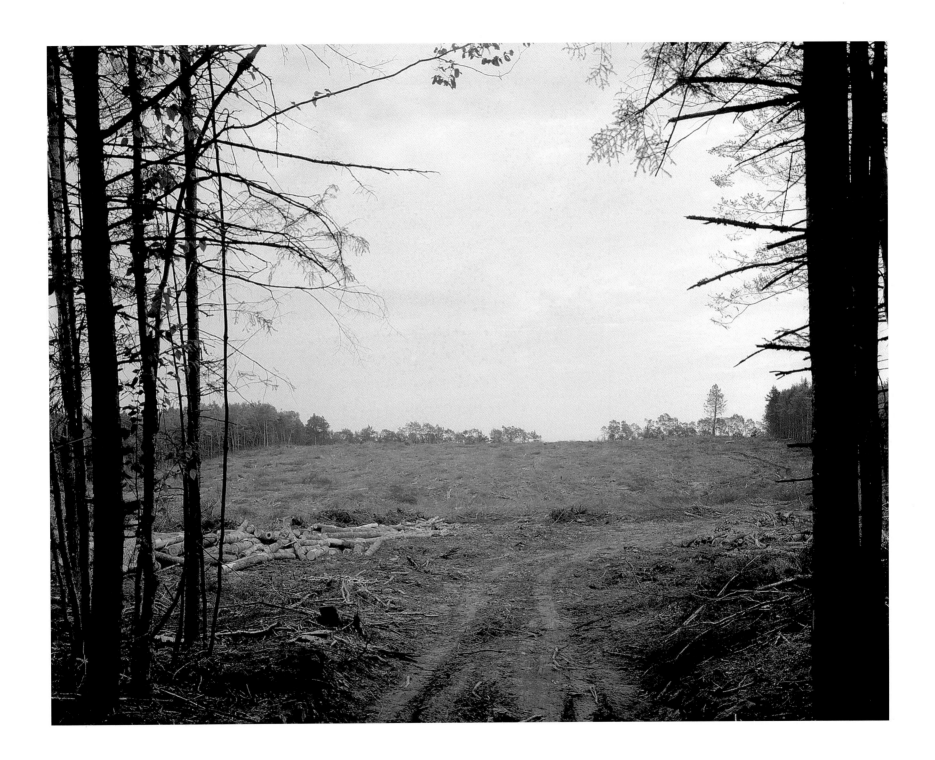

The habitat of Pileated Woodpeckers in eastern Canada has evolved under the influences of Dutch elm disease. They now use farm fencerows and woodlots, much as the Great Black Woodpecker of Scandinavia. Habitats can change in response to landscape changes but how much change can be tolerated is not predictable. Species are lost if rapid and extreme landscape change occurs and species composition of the fauna and flora is changed by almost every modification of the habitat mosaic that makes up the landscape.

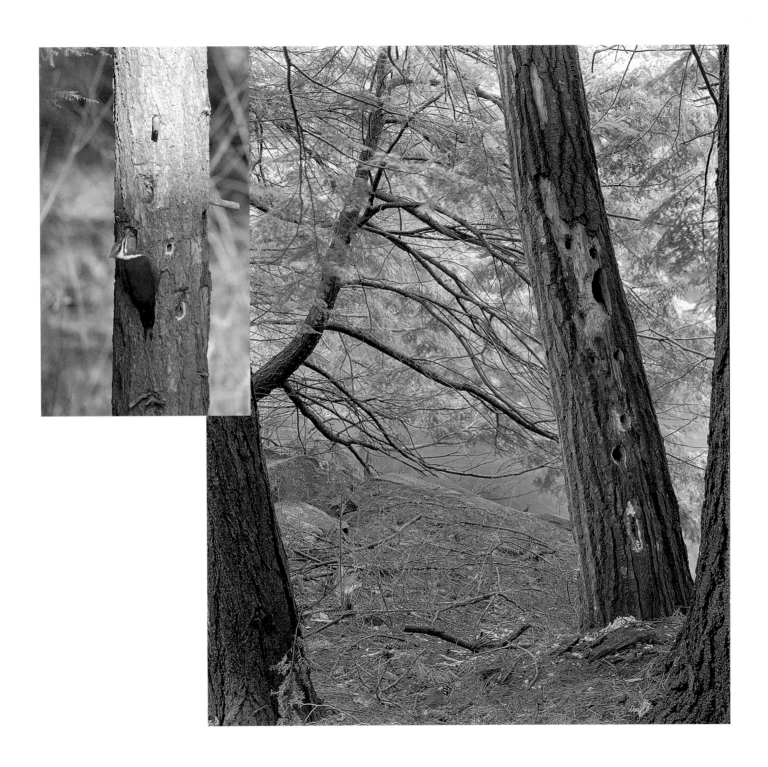

Species' attempts to adapt to our impacts on their habitats can be deadly. Snapping turtles trying to use road embankments for egg laying and incubation probably lower the average lifespan of the females enough to threaten the survival of this ancient species.

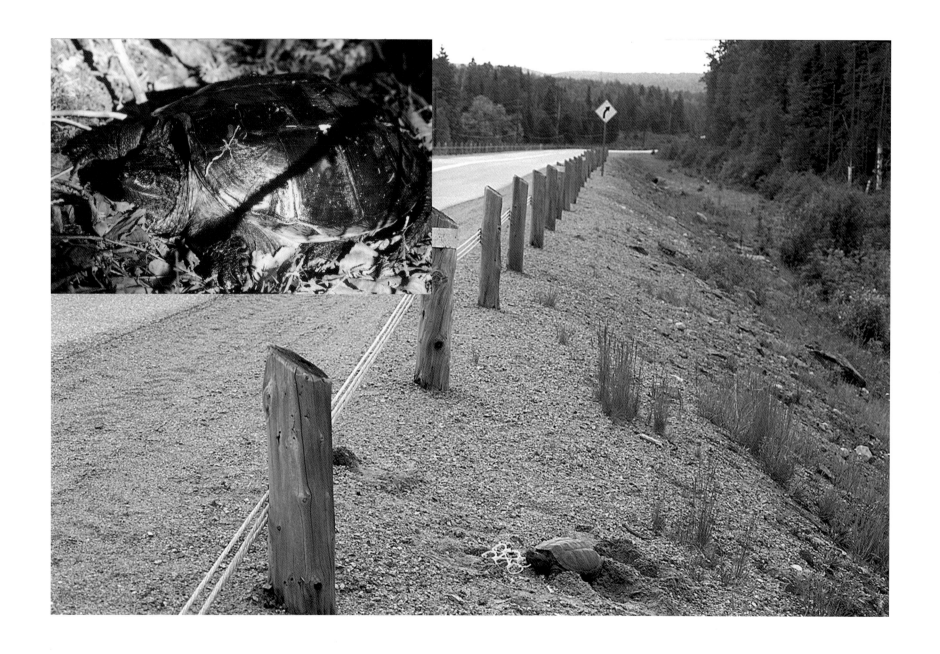

A patch of high productivity in nature is like a ball of raw hamburger on a lawn. They will come and they will carry it off. Such a concentration of resources will cause a flow of energy that will connect patches in a habitat mosaic — an ecological system — a landscape.

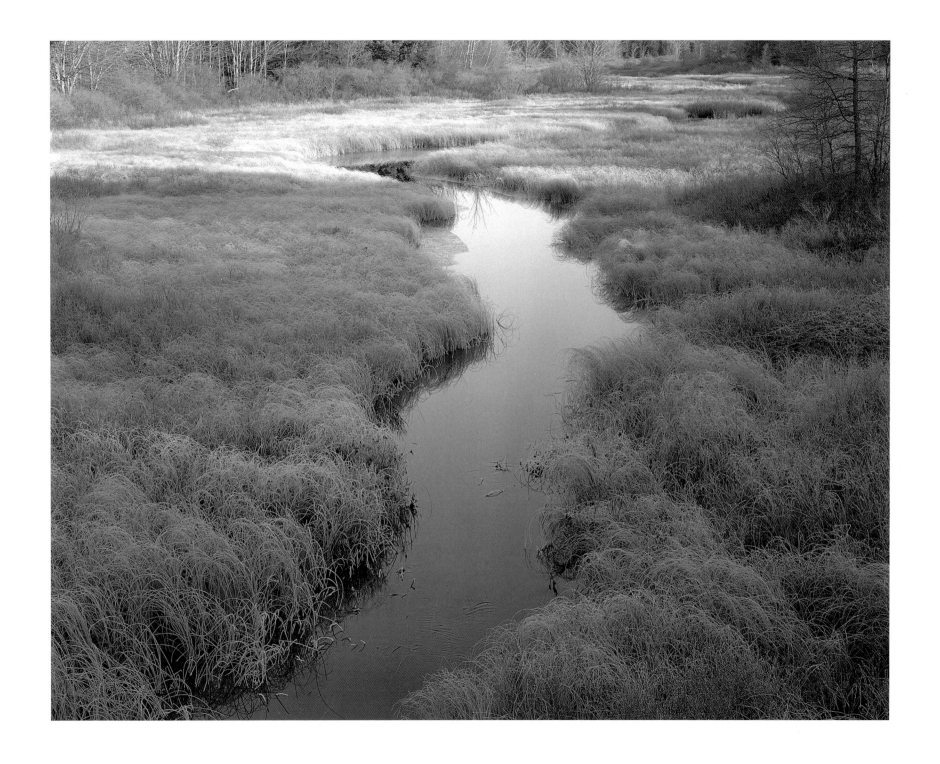

Fragmenting habitat has a complex of effects. Amount of habitat is reduced. Habitat patches are separated by space that may be dangerous, repulsive, or resource-rich. There is more habitat edge and less habitat interior. And all these effects often are imposed too rapidly to permit any evolutionary response. Change in behaviour, or in mortality, natality, and population survival may be the only options.

Construction and maintenance of roads for human traffic is a major influence on habitats for other species. Our roads fragment habitats, acting as complete or partial barriers to the movement of some species. Fragmentation can block access to habitat essentially removing it. Noise from large highways can prevent nearby nesting by some birds. Maintenance of roads without attention to environmental guidelines has many effects. Primary among them is causing nutrient flow into waterways and wetlands.

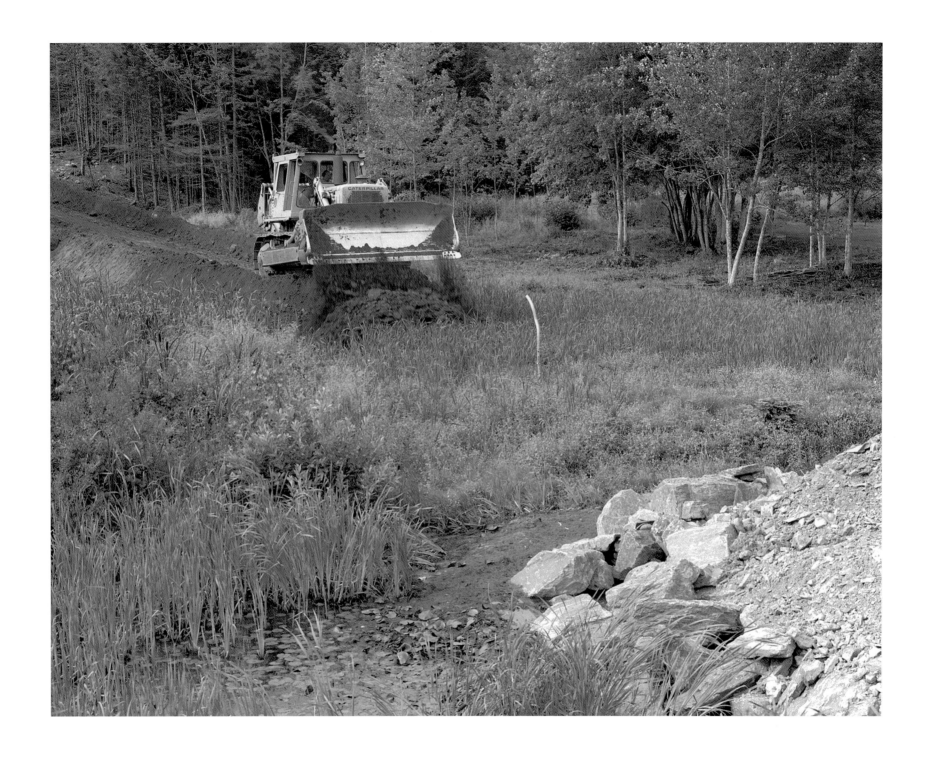

We humans have realized the importance of freely
moving over long distances across our landscape .
But we design our movement corridors with slight
attention to how our corridors block the movements
of many other species who share our landscapes.

A WEALTH OF LIVING THINGS

biological diversity

WITHIN ONE ENVIRONMENT there is more than a single species and more than a single habitat. The group of species that can be expected to be found living together is often called a community. Apparently they live together because they can fill all their resource needs from a shared environment. Each species has its own habitat. Each species has its own special set of detailed requirements. That set of resource needs and the species' set of environmental limits often are called its ecological niche — the species' way of making a living.

If there is a way of making a living, there likely is a species doing it. The number of ways of making a living in any environment depends on the total amount of plant production, which feeds everything else, on the secondary production of animals that it permits and on the infrastructure formed by both. But, for any given amount of plant production, there are many fewer ways to make a living if there is only one kind of plant. The diversity of living things generates the variety of ways of making a living. Many types of plants allows many types of herbivores and many types of herbivores allows many types of carnivores, and all of these allows many types of decomposers. The number of different niches in an environment depends very much on the diversity of life forms, not just the amount of production.

There is a limit to the diversity that is possible in particular environments. In arctic tundra, the living conditions are difficult. Growing seasons are brief. The total amount of solar energy getting into the environment is low. Permafrost limits soil development, and nutrient supplies are limited by both the poor soils and the

decomposition rate, which is slowed by low temperatures and poor drainage. Only a few kinds of plants can survive these conditions. Similarly, herbivores may take several years to make it through one life cycle. Only a few types of such herbivores are able to maintain successful populations on the arctic tundra.

> Two moths that live on mountain avens on Devon Island take over ten years to move through egg, larva, pupa and adult stages.

Species that are successful in the arctic often have outstanding numbers of individuals. Highly adapted caribou can be seen in countless numbers. But no other mid-size or large herbivores can maintain such numerous and successful populations under the conditions. Muskoxen have fallen to threateningly low numbers in the recent past. In coastal tundra of the high arctic there is only one numerous large carnivore — the polar bear. This magnificent animal has adapted to use the coastal land together with the sea and from the two can satisfy its full set of needs. The Inuit also found that both coastal land and sea were necessary to survive.

Compared to the Carolinian zone, the arctic tundra supports a very small number of plant species. Compared to the tropics or the African grasslands, the tundra, with just one large carnivore species is low on the diversity scale. The first conclusion from these observations is that conservation objectives should not be to maximize diversity anywhere. Rather we should try to conserve the characteristic diversity of each environment. A

second conclusion is that loss of a single species from the tundra environment will cause a much more serious disruption of the ecological processes in that system than will the loss of a single species from the more diverse southern environments. If our impacts displace a single species from a low-diversity environment, that ecological system may be severely distorted and possibly not able to maintain itself.

Worded differently, we should not focus our concern about biodiversity only on the so-called 'hot spots,' where diversity is so great that it pleases us greatly. We should not value diversity simply by counting species. They are unequal in ecological value. 'Rare' and 'common' do not translate directly into biodiversity values. The functional roles of species in their ecological system should be considered together with the values we place on beauty and rarity.

However, species do take on equal value at their extinction. Each species is irreplaceable and each loss is absolute. So we hear a lot about biodiversity, but relating that concept to natural processes and to the functioning of ecological systems is less clearly and less loudly spoken. Some things are clear. High diversity is not normal for all environments. Rather, each environment has a characteristic normal diversity. Conservation managers should aim to maintain the normal diversity. Diversity above the norm may result from entry of opportunistic species not characteristic of the site; moreover, this abnormally high diversity may open the environment to even more such species. These opportunists may be native species from other Canadian environments or they may be exotic species imported from other continents. Either is a distortion of the ecological system that they enter. Both often accompany a disturbance. The disturbance may be removal of native species or simply exposure of the ecosystem to entry by exotic competitors to which the native species have not been exposed historically. Bulldozed 'vacant' lots and cleared power lines are familiar extreme examples.

Introduction of exotics, whether Canadian or foreign, has been and is a most important cause of change in biodiversity. Introduction of exotics has been both willful and unconscious. Unfortunately, for unclear reasons, European species have shown a remarkable ability to thrive in Canada whether invading directly or via the United States. The same is true for some Asian species such as the carp. Such invaders often show an explosive burst of population growth at some time in their invasion. Often this is early but, as in purple loosestrife, it may wait until habitat conditions are changed by human activity or climate change. This population explosion and accompanying geographic spread often is followed by a burst of public and media attention. Both bursts may fade as the dramatic rate of expansion calms and the invader settles into a stable competitive existence in a new floral or faunal composition created by its actions.

In 1904, four moose were transplanted from the Maritimes to Newfoundland. That small group has since produced an estimated half-million offspring that continues to change the ecological, social, and economic relationships in Newfoundland. Distortion, certainly, with both acceptable and unacceptable consequences.

This distorted biodiversity tends to be practically impossible to readjust with normal funding and, unless the invader is a direct threat to human health, after a time, it elicits little attention from us. Some invaders, such as agricultural 'weeds' go on control lists. Some others, depending on perceptions and economic valuing, can become fully accepted, along with their distortions of our biodiversity.

After the alewife was introduced into the Great Lakes and its population exploded, it began taking the food supply of native species. So, Pacific salmon were introduced into the Lakes to 'control' the alewife. The salmon thrived and became a valued game fish. An industry was built around

them. The alewife now is considered a valued food fish that supports a valued game fish industry. Effects on native species, such as lake trout, have been set aside. Restoring native biodiversity from such distortions is extremely difficult both technically and economically.

Attempts in Scandinavia to remove imported Canadian beavers and restore European beavers to the local fauna have been prolonged and expensive. There has been no attempt to remove our beavers from the Darwin Range of the southern Andes in Tierra del Fuego; it is just too costly. We succeeded in eliminating Finnish coon dogs from Ontario only because efficacious decisions by wildlife scientists destroyed an imported colony before they were released into the wild; their spread in Europe has been uncontrollable.

Very low diversity does occur normally in some environments. Some marshes are dominated by very few species and yet are very highly productive. High net primary production results from most of the plant tissue having 'green magic' and little tissue that uses energy but does not trap it. Grasses and reeds are like this — trees are not. Low losses to herbivores also boosts net primary production of the community. These are the design principles for farming. In any field, the farmer tries to allow only one type of plant — the crop — and no herbivores. These highly productive but simple, low diversity systems risk the possibility of an outbreak of some herbivore or disease. Such pest outbreaks can remove most of the base of 'green magic' from a community. A comparable disturbance is much less likely in a diverse community simply because a single pest will be less likely to devastate all the different species present.

It also is clear that if ecological systems are to continue evolving as environments change, diversity of species and, within them, genetic diversity in populations will be the necessary stocks from which better-adapted types can be selected by nature. If we can shed the cloak of arrogance put on us by historical humanism and outdated religious beliefs, we will do well to acknowledge our responsibility to foster the greatest of all natural processes — evolution.

Biological diversity of a place reflects the number of ways to make a living in that place — the number of ecological niches.

New, empty, available, ecological niches may be produced by our technology. Your contact lenses are an example. All the other niches were filled long ago, even if we don't know about them. A simplistic but helpful precept. Because ways of making a living in nature depend so heavily on other living things, as we reduce the number of living things and the number of their kinds, we also reduce the ways for others to make a living.

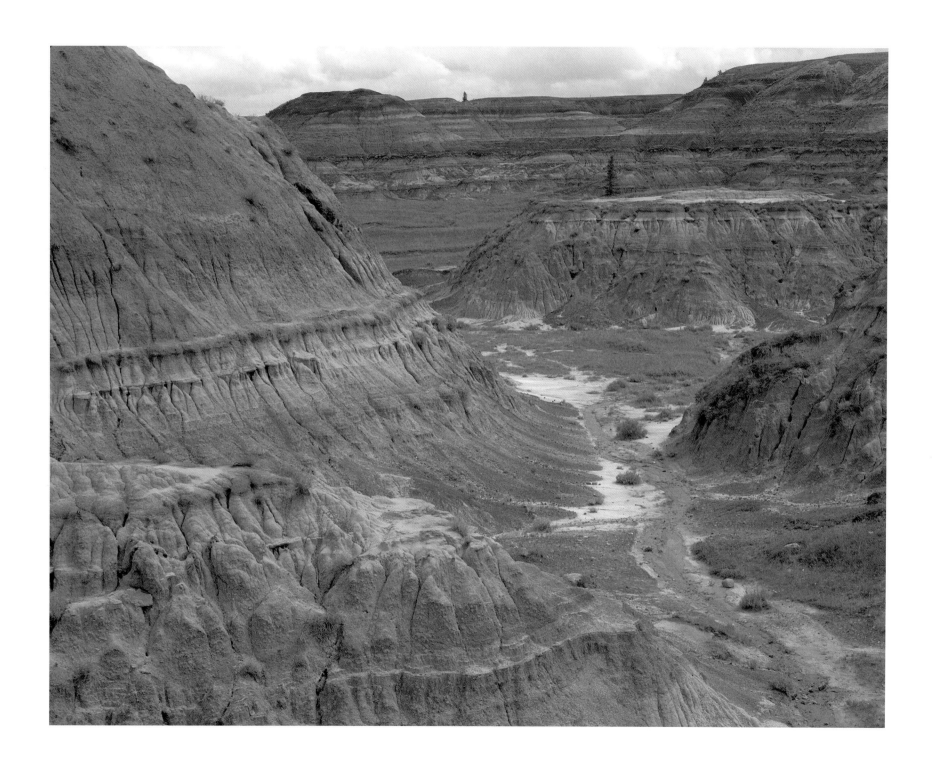

The number *of individuals* of a species may be very high where the number *of species* is not high — as in the arctic. Loss of one species from such an ecosystem can have much greater impact than loss of a single species from a high diversity system. Simple counts of the number of species (or genotypes) is not a substitute for assessment of the importance of a species to its ecosystem.

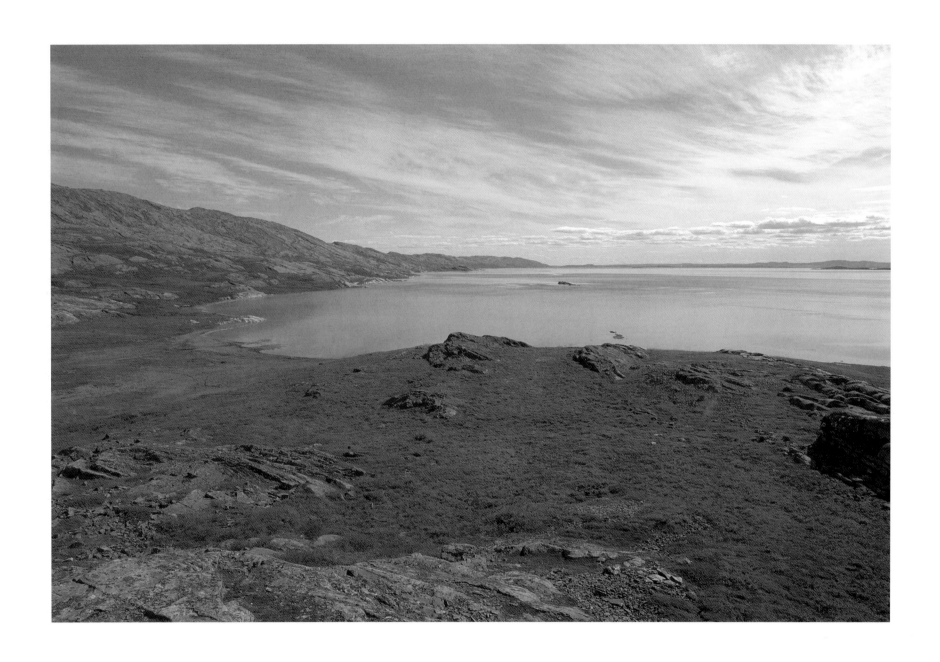

Some low diversity assemblages are very high in primary production. Species from surrounding areas of the landscape may depend on these low diversity areas as feeding grounds. Which is more important — diversity in a habitat or the role of that habitat in ecosystem processes over the whole landscape or region?

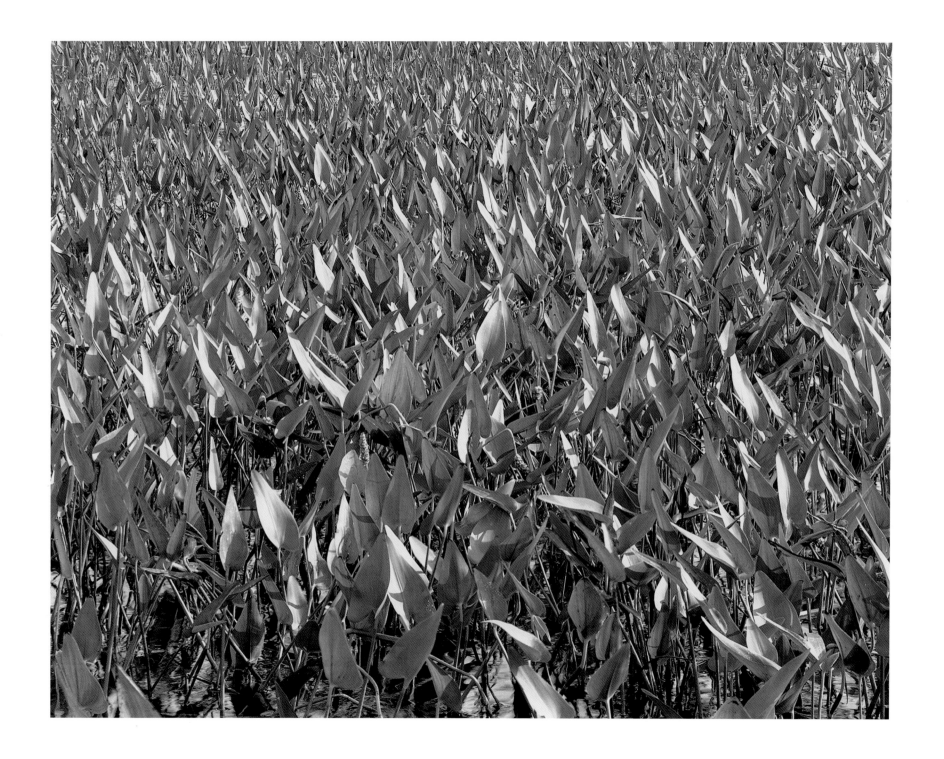

Farming, whether wheat or trees, tends toward the principle that a single crop species with no competitors and no herbivores will produce more of the target crop. Objectives for wheat fields and for forests should not be confused.

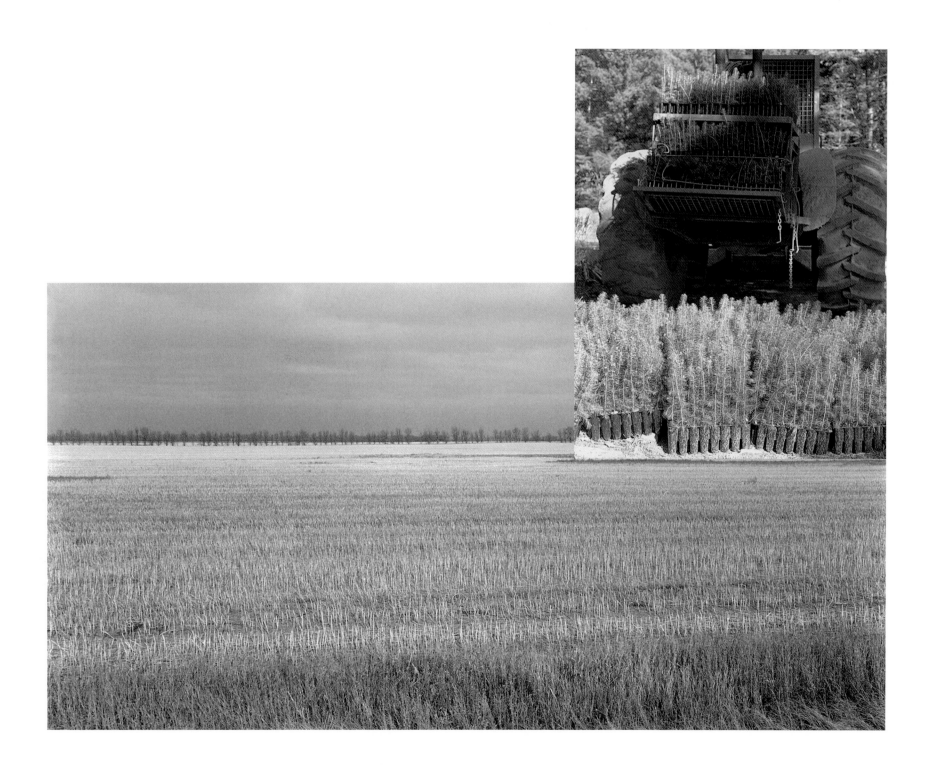

Ferns. Ancient primitive plants. Look at them. Walk among them. Taste some. Value them. Intellectually. Emotionally. Aesthetically. Obsolete? Weeds?

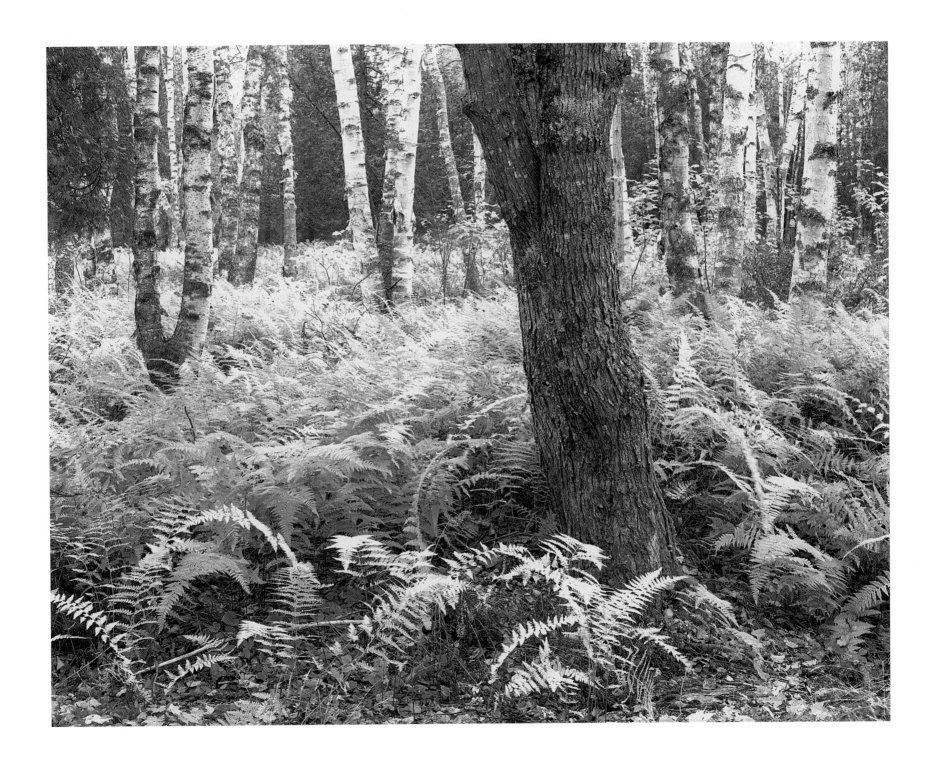

MAINSTREAM

cycling water

A WORLD WITHOUT WATER. Even considering it is impossible. Virtually no work by living systems is possible without water as solvent, medium, and component part. Water also is the intermediary between living processes and those non-living, physical and chemical surroundings that bring non-living processes to bear on the living. Water makes the line between living and non-living quite fuzzy. The March rise of maple sap up into the trees — and our buckets — moves nutrients into position for building green magic factories in the leaves, and it all depends on water as the transporter. So does the chemical structure of the leaf tissue and the hydraulic pressure supporting each cell. Considering the ubiquity of water in life processes, one easily could assume that water is everywhere and in abundance. But living things stand out in their environment partly because they have ways of capturing matter that is relatively rare and concentrating it into their own being. They do it with water, too.

Plants move massive amounts of water up from the soil, through their tissues, out through pores in their leaves and into the air — a process called evapotranspiration — a combination of the non-living process of evaporation and transpiration, the life process of moving water through the plant.

To produce 20 tonnes of corn requires the corn plants to move about 2000 tonnes of water out of the soil, and to release over 1980 tonnes of that for evaporation from their leaf pores. That is why trees will dry up a wet area.

Over 94 percent of the water on earth is not liquid water but is part of rock molecules. Liquid freshwater is on the land only as a transient flow. Liquid water is just over 5 percent of all global water. Of that liquid water, only 0.064 percent is freshwater. And only a dribble of that (0.02 percent) is not icecaps (currently). Almost 99 percent of all liquid water is saltwater. If gravity had its way, all freshwater would flow off the continents back into the oceans. But water captures heat and uses it in evaporation to overcome gravity. Cooled water vapour gives us rain. Thus freshwater flows on the land.

Some of the freshwater on land is actually under the land. Groundwater supplies springs, some in lake and river beds and wetlands. Humans tap into groundwater with wells as a source of drinking water. But we use it in many ways and so the groundwater levels and flow rates are drawn down. In some places the Ogallala groundwater reservoir that underlies much of central North America has been drawn down so severely by wells supplying agricultural irrigation that wells have had to be deepened repeatedly. Farmers have been paid a 'water depletion allowance' to compensate them for the increased difficulty in drilling for and pumping water from the Ogallala. Groundwater reservoirs and flows have to be recharged by infiltration from surface water or they may be depleted. The springs and seeps that they normally supply and the living things and natural processes that depend on them will lose their supply if the recharge and removal of groundwater are not balanced.

About 23 percent of the incoming energy from the sun is used to evaporate water. That energy ends up as latent heat stored in the resulting water vapour. It is only heat and you can't eat it but without it none would eat.

Evaporation of ocean water into the atmosphere moves about 99 trillion cubic metres of water from the oceans back onto the continents as rain every year. Without this purely physical process, no more green magic. What a marvellously functional and inexpensive distillery, giving the continents freshwater from saltwater of the oceans!

When that water vapour gets into a cool layer in the atmosphere it sheds its load of latent heat and falls as rain. Much of its heat load radiates toward outer space and so we get rid of the excess heat left over from incoming energy from the sun. A free temperature regulator for earth thanks to water's special ability to transport heat.

The latent heat stored in evaporated water also is a most powerful generator of weather events and patterns. Hurricanes do not get too far inland, because they are powered by heat contained in evaporated water, and when not over water, they rapidly lose power. Heat contained in evaporated water differentially heats both air and water causing currents, in both air and oceans, that also are major determiners of weather and climate patterns.

Because water has such a high capacity for absorbing heat even before it evaporates, it is a powerful moderator of temperature change around lakes and oceans. As temperature tries to rise, the water absorbs a large amount of the heat and slows the change of temperature. At our northern latitudes the opposite effect also can be called moderation. In spring when increasing energy from the sun tries to warm everything quickly, each gram of ice demands its ration of heat to melt with. Thus the temperature rise is slowed, and for many natural processes this moderation is vital. Too sudden heating can be difficult to accommodate and early bursts of heat can be followed by resumption of freezing cold. Precocious bursting of buds and production of 'soft' tissue with no antifreeze protection can be damaging to plants, and cause vital delays when spring really comes. Similarly, unmoderated temperature can 'break' dormancy in plants or in some animals (diapause) putting living things into a physiological state in which they are open to damage by renewed cold or require energy-costly avoidance responses.

The intimate linkage between water and heat energy potentially can have sub-continental effects if ice cover is unduly modified. Ice effectively blocks the flow of heat between the air and the water. People around the Great Lakes are well aware that severe snow storms decline as the lakes ice over. Interventions to extend shipping in the Gulf of St. Lawrence could easily affect climate and weather patterns of surrounding land masses. Global climate warming seems destined to have such effects soon.

Over two and a half million cubic metres of freshwater each year drain off the 2 million square kilometre watershed of Canada's Mackenzie River. At Canada's other corner, the St. Lawrence carries over 2 million cubic metres per year from just the Canadian side of its drainage basin. In every second, over 100,000 cubic metres of freshwater flows off Canada and back into the oceans.

The rain on the land masses supports green magic, but it also gives us other extremely special by-products. Lakes and rivers temporarily hold water on its way back to the oceans. But the reliable rain process renews their water and keeps them full most of the time.

Together with the sculpting by the geological processes and the mantle of plant structures clothing all their shores, lakes and rivers transform landscapes into tantalizing spirit food.

For many, winter's snow, also, is food for our spirit. Without snow, the procession of the seasons would be less rich. Snow and

ice are a kind of renewal. With snow and ice, natural processes give us sculpted structures that are possible in no other medium. Snow gives insulating respite to many organisms, and to others it allows a second lifestyle possible in no other way. Reradiating heat from the earth under the snow mantle reforms snow crystals and creates a new living space under the snow — the subnivean. Here in the dead of winter many so-called cold-blooded organisms carry on a second life.

With air temperatures above the snow dipping to minus 35 C, the temperature in the subnivean space under one and half metres of snow may be plus one-half degree.

At a few degrees above freezing wolf spiders chase prey, springtails jump around, and daddy-long-legs cavort, upside down, hanging from the snow crystals above. Club mosses stay green and maple seeds send their sprouts up to penetrate last year's soft, brown leaves while there is still a metre of snow above.

Water, too, has magic.

A thin veil, freshwater is a vital, sensuous and transient layer on the land.

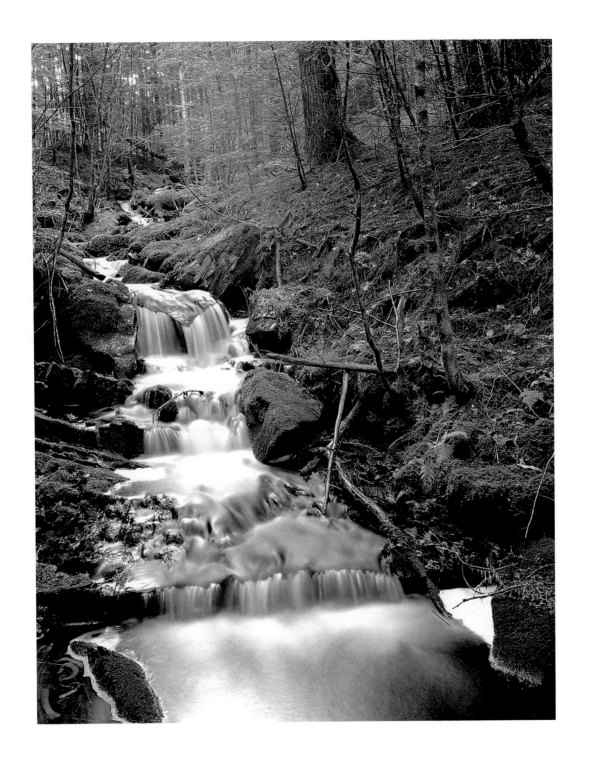

Ever moving back to the oceans, freshwater is slowed in its journey by natural water storage-reservoirs. Like living sponges, they may purify the water by physically slowing it, causing particles to sediment, and by chemically processing the water through living beings. In some cultures, we have adopted an unthinking response of drainage and filling valuable natural water treatment amenities. How do we judge the advisability of destroying a particular water storage or purification feature of the landscape? Uncoordinated individual ownership rights? Watershed balance sheets? Continental climate models? Society's acceptance? Macroeconomics?

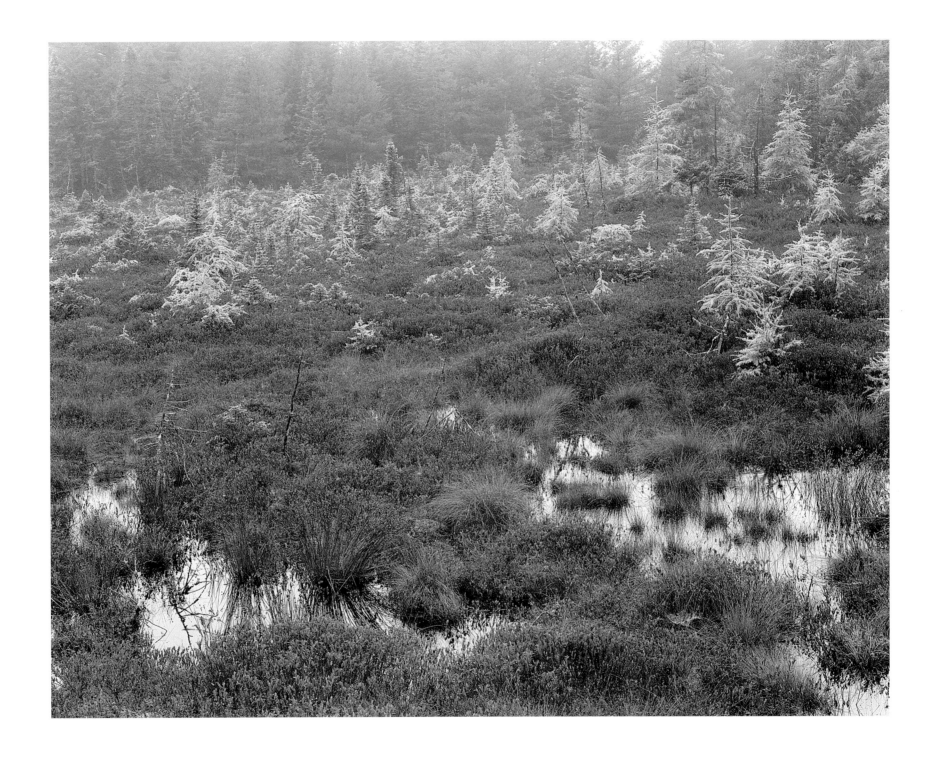

Return flow of freshwater from the oceans to the land is powered by solar energy. The sun provides the power for evaporation to move water into clouds and for air currents moving that water back over land, where storms return it as rain. This is one of the largest, most profitable industries on earth. Without it? Yet we continue to think of all the components as 'free goods.'

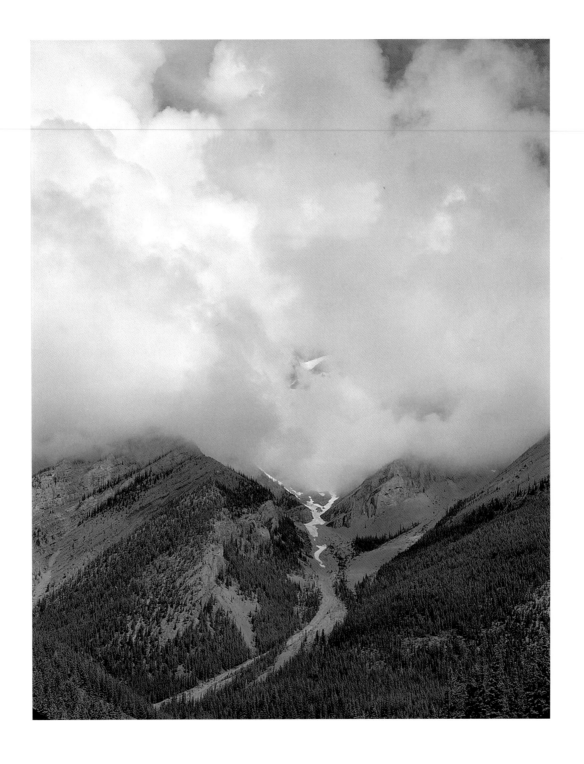

Solar power that causes evaporation from the oceans puts unimaginable amounts of energy into the atmosphere as heat stored in water vapour. That heat makes air currents, weather patterns, and storms. Hurricanes over oceans receive that unstoppable power, but when they move over land, they starve for lack of heat from evaporation. Human technology has never managed smooth flows of energy that are even comparable. Nor could we supply technological substitutes for atmospheric forces — not even just for our supply of rain.

As Little Round Lake, near Sharbot Lake, Ontario, melts out in spring, it does so with moderation. Each gram of ice requires 80 calories of heat from the air to melt. This absorption of heat slows the rate of heating of the air. Thus organisms are able to move from winter to spring conditions less harshly. The reverse happens at freeze-up. (Little Round Lake is a world-famous meromictic [partly mixing] lake, with chemical-laden bottom water that has not been near the surface or gained any oxygen in centuries. Purple sulfur bacteria like it.)

Freshwater dances off the land and back to the oceans. A sensory dance — full of force. White horses at full gallop but murmuring gently. Stimulating. Calming.

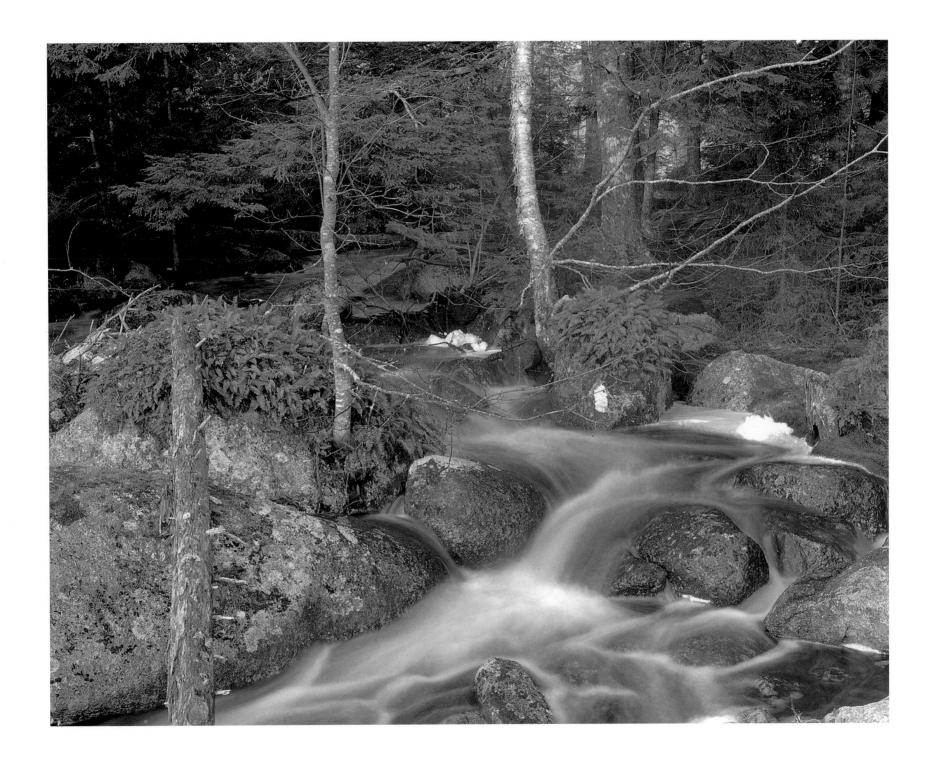

Lakes and the mantle of vegetation surrounding them are a cardinal feature of many Canadian landscapes. They make up part of our national 'home place.' Part of our cultural identity. How should we value such things? We should have a clearly outspoken way.

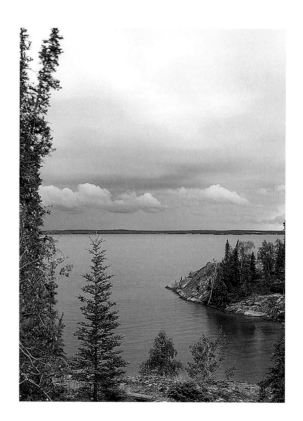

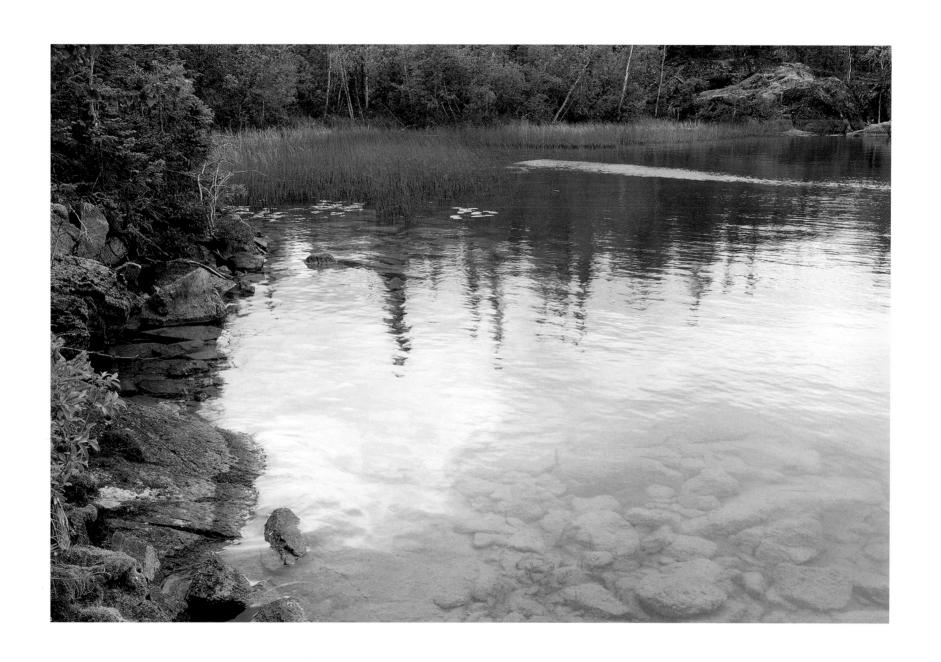

The atmosphere of lakes. Science fails. Economics pales. Politics is nowhere near. But it is real, it has high value, and it can be known.

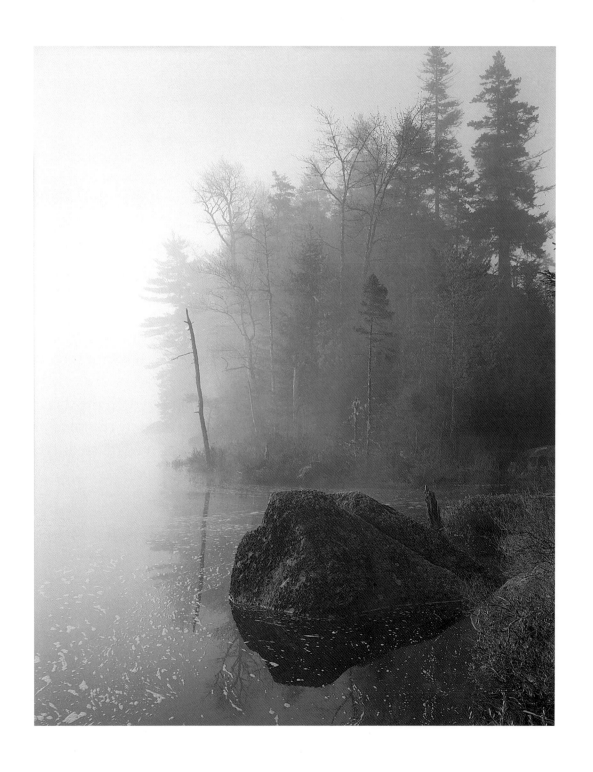

Water comes to Canada in three phases: liquid, gas, and solid. Without considering snow and ice, our understanding and our culture would be incomplete. So would our ecology. Many organisms and many ecosystems would fail without adaptations to snow and ice. Snow insulates winter quarters for many, trapping enough heat reradiating from the earth to tip the critical balance to survival. We face snow in practical ways, but we also have entire volumes devoted to both the thermodynamics and the aesthetics of snow crystals. Some of our languages have several dozen words to distinguish types of snow.

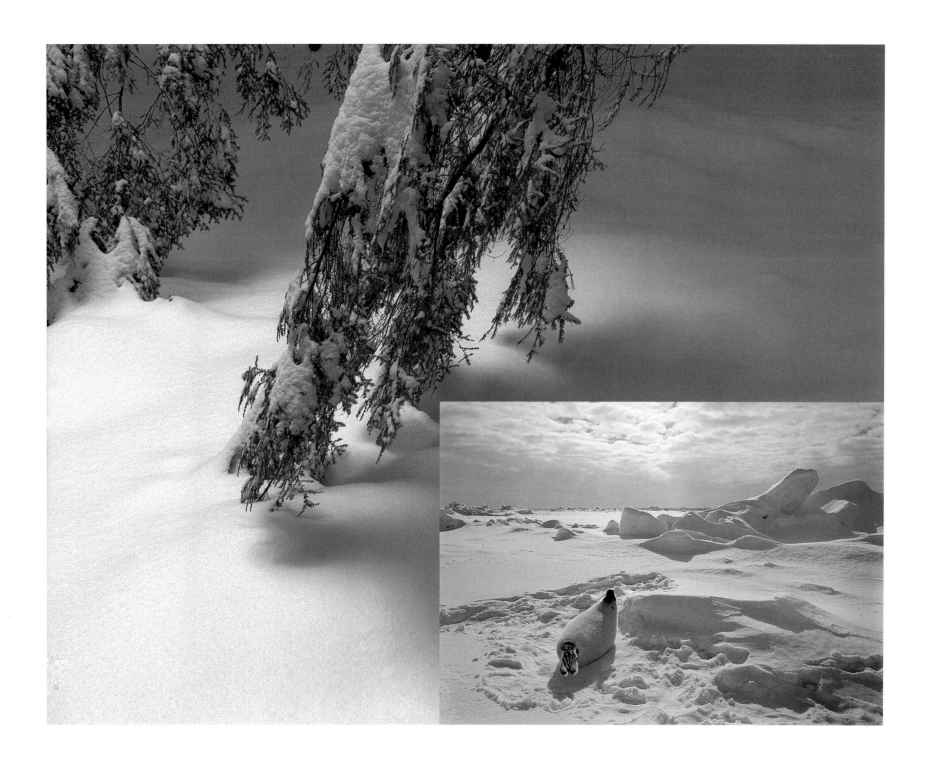

ARRIVAL

some understanding

HUMAN CULTURE IS the principal variable affecting our environment. Undeniably. And our environment is the principal variable affecting human culture. Ultimately. We can change the interaction of the two. We need assistance in our judgment here, and that assistance cannot come solely from science and technology. Humans will make better decisions about how to interact with their environment when they are sensitive to the pure joy added to their culture by environmental processes and when they acknowledge and accept the laws and limits revealed by science and reason.

Discovering natural processes can increase our sensitivity to interactions between our environment and our culture and thus can increase the wisdom of our decisions affecting those interactions. Understanding natural processes and choosing the appropriate scales of time and space to match particular questions can influence the quality of our decisions powerfully. Yet criteria for these decisions may still seem abstract.

Perhaps the abstraction can be lessened if we use our knowledge of natural processes to understand the workings of a real, down-on-earth environment. We hope to take you another step in the journey with another book, which will present some examples of special places that will let you look at the biological and the physical structures in a particular environment and interpret those structures in terms of the natural processes of that place. For example, the silt that is freed by the melting toe of the Kaskawulsh glacier in Kluane National Park adds to the mud of the 'Silty Slims' River. Then wind deposits some of it up on the Burwash Plateau. This 'silt fertilization' makes the uplands ecologically productive, resulting in the regal rams of the Dall sheep herds. Interpreting the structures of the environment in terms of the natural processes that built and maintains them is both challenging and satisfying.

We hope to prepare this challenge for you and to help you gain this satisfaction. Our plan is to prepare another book, called *Special Places*. It will present images from a selection of special places from each of Canada's ecozones. These special places will be selected not just for their aesthetic qualities, but because we can also offer satisfying explanations of the interactions of their natural structures and their natural processes. We hope that your journey through *Discovering Natural Processes* has combined with your personal journey through life's experiences to provide a fresh insight. That 'way of knowing' should enable your full appreciation of the sample of Canada's special places that we will present. It will be only a taste of Canada's 'natural wealth,' but it will make your mental and geographic journeys more complete and more enjoyable.

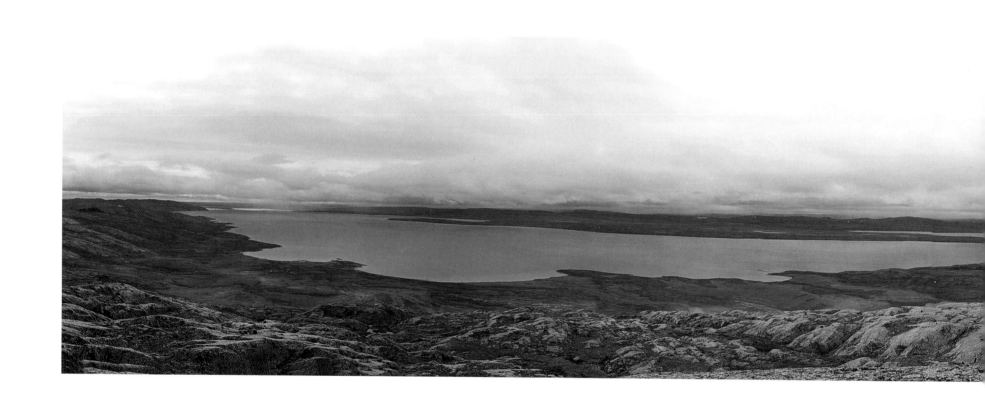

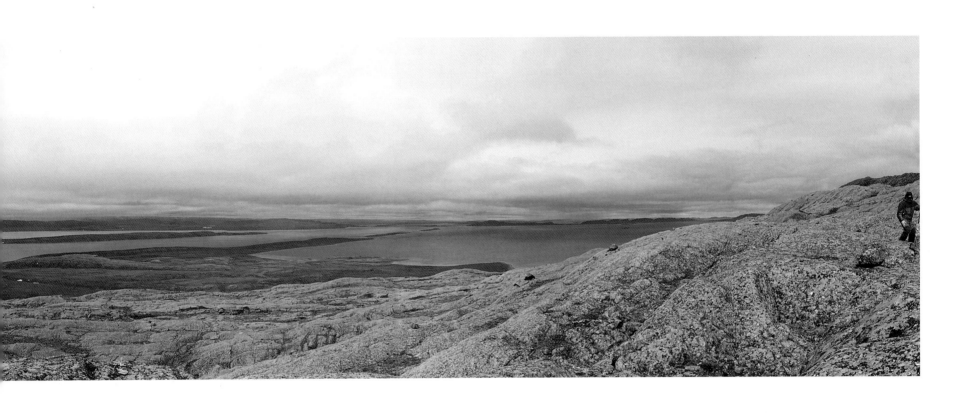

GEOGRAPHIC PLACE NAMES

With all the miles, and all the places, it has become very clear to me that it is not the 'special' places, the exotic locations that yield an image. It is simply those places and moments where an image appears, that become exotic. Those places are around every corner, literally, under our very feet. I have taken careful notes of place over the years to present just these observations. Please note — the designation (GM) signifies Gray Merriam as photographer.

PENUMBRA
PRESS

ARCHIVES
of
CANADIAN ARTS
CULTURE & HERITAGE
www.penumbrapress.com

This is a first edition in the Archives of Canadian Arts, Culture, and Heritage series published by Penumbra Press.

LIBRARY AND ARCHIVES CANADA CATALOGUING IN PUBLICATION
Amos, Jeff, 1949-
 Discovering natural processes : beauty in nature's ways / photography, Jeff Amos; essays and captions, Gray Merriam.
ISBN 1-894131-74-6

 1. Natural history–Canada–Pictorial works. 2. Natural history–Canada.
I. Merriam, Gray II. Title.
QH106.M47 2005 508.71
C2005-902572-7

Type set in Cartier Book and printed on Hanno Art Silk. Dust Jacket is Horizon Silk.

Canadä

Penumbra Press gratefully acknowledges the financial support of the Government of Canada through the Book Publishing Industry Development Program (BPIDP) for our publishing activities. We also acknowledge the Government of Ontario through the Ontario Media Development Corporation's Ontario Book Initiative.

TO ACKNOWLEDGE ...

For putting up with all the miles spent away from home finding the places to illustrate, and the words to communicate, we thank our partners, our wives — Jacquelyn and Aileen. We're also hoping this helps for all the miles to come, on the next book! — JA & GM

To acknowledge the landscape of Canada seems a must when it means as much as it does, both to this effort and to me personally. Having been back and forth, up and down, since I was 3 weeks old, gives me a very large sense of home — this place called Canada, with all its incredible variations.

 And I wish to acknowledge my long time friend, Gray. We have been student/professor together, dreamers, thinkers, travellers together — all of which is a deep part of me.

 A little PS — the use of language in this book does not attempt to conform to the standards of either scientific or artistic literature. Rather, we have tried to communicate freely and openly with all non-specialists, who happen to be most of us. — JA